THE EMPORDÀ TRIANGLE

photography by JORDI PUIG with text by SEBASTIÀ ROIG

TRIANGLE ▼ POSTALS

PUBLISHED BY
FUNDACIÓ GALA-SALVADOR DALÍ
TRIANGLE POSTALS, S.L.

DIRECTION
Jordi Puig

ARTISTIC DIRECTION
Ricard Pla

EDITORIAL CO-ORDINATION
Jordi Falgàs,
Fundació Gala-Salvador Dalí
Jaume Serrat, Triangle Postals

TEXT
© Sebastià Roig, 2003

PHOTOGRAPHY
© Jordi Puig, 2003

Page 8, Xavier Miserachs
© Miserachs / Fundació
Gala-Salvador Dalí, 2003
Page 13, © Batlles-Compte
Page 32, Melitó Casals "Meli"
© Melitó Casals / Fundació
Gala-Salvador Dalí, 2003
Page 100, Francesc Català-Roca
© Català-Roca / Fundació
Gala-Salvador Dalí, 2003
Page 186, Man Ray
© Man Ray Trust, VEGAP,
Menorca, 2003
Pages 1, 2, 3, 4, 5, 9, 33, 101, 187 & 240
Caligraphy studies by
Salvador Dalí, © Fundació
Gala-Salvador Dalí.

WORKS BY SALVADOR DALÍ
© Salvador Dalí,
Fundació Gala-Salvador Dalí,
VEGAP, Figueres, 2003

ARCHIVE PHOTOS
Centre d'Estudis Dalinians,
Fundació Gala-Salvador Dalí

POSTCARDS FROM THE PERIOD
Collection Josep M. Joan i Rosa

PRODUCTION
Imma Planas, Paz Marrodán

DESIGN
Joan Barjau

DIGITAL RETOUCHING
Pere Vivas

LAYOUT
Mercè Camerino,
Antonio G. Funes,

TRANSLATION
Steve Cedar

PHOTOMECANICS
Tecnoart

PRINTED BY
NG Nivell Gràfic. 7-2007

LEGALLY REG.
B: 34.781-2003
ISBN
978-84-8478-111-0

© TRIANGLE POSTALS S.L.
Sant Lluís, Menorca
Tel. +34 971 15 04 51
Fax +34 971 15 18 36
www.trianglepostals.com

WE WOULD LIKE TO THANK
Montse Aguer, Elisenda Aragonès,
Jordi Artigas, Georgina Berini,
Francesc Campi, Anna Capella,
Joaquim Chicot, Irene Civil, Núria
Ferrer, Valentí Garcia, Josep M.
Guillamet, Yvonne Heinert, Josep
M. Joan i Rosa, Paquita Llorens,
Rosa M. Maurel, Ferran Ortega,
Imma Parada, Antoni Pitxot, Joana
Planet, Josep Playà, Carme Ruiz,
Miquel Sànchez, Joan Manuel
Sevillano Campalans, Biblioteca
Fages de Climent.

DALÍ 2004

Contents

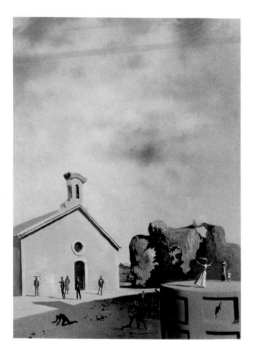

BREAD ON THE HEAD OF THE PRODIGAL SON, 1936. Private collection

It is difficult to understand the personality and work of Salvador Dalí without knowing the three Dalinian centres par excellence. In the first, the house in Portlligat, is the essence. In this house Dalí lived, created and transformed, penetrated by scenery, light and isolation, which conditioned, influenced and inspired him. Of this house, I would like to emphasise the most important area: the workshop, the place of inspiration, refuge, concentration and work, located where the best light possible is captured.

Dalí explains about Portlligat: "It was where I learnt to become poor, to limit and file down my thoughts so that they would acquire the sharpness of an axe, where blood tasted of blood and honey of honey. A life that was hard, without metaphor or wine, a life with the light of eternity".

The castle of Púbol, the fortress and refuge for Gala, the visible wife, is more austere. There are no accumulations, it is more severe and mysterious and it fascinates us. Here we discover a mature Dalí who pays homage to Gala, his muse, and he provides her with a space where she can be free. For Dalí, it would be a place for reflection, for thinking about illness and death. Nevertheless, the castle is bright, full of symbolism and small ironies that speak to us of a unique couple: Gala does not like the radiators, hides them, and Dalí paints a *trompe l'oeil* of, precisely, radiators.

The Dalí Theatre-Museum of Figueres, opened on the 28th of September 1974, is the accumulation, the plenitude and the totality. It is the theatre of the memory, full of allusions to the artist's life and work, extremely localised and universal at the same time. As the artist himself states, "The Museum should not be considered as a museum, it is a gigantic surrealist object, everything inside it is coherent, there is nothing that escapes from the webs of my understanding".

The courtyard of the stalls of the old theatre, where the famous rainy Cadillac-Taxi is installed, is an invitation to a Dionysian party: our visit to the Museum. Here we find the inexperienced Dalí, who seeks out his own path, who experiments with diverse styles: the nineteenth-century art movement, impressionism, futurism, pointillism, cubism... and the surrealist Dalí of *Moon and Decaying Bird, The Spectre of Sex Appeal* or *Napoleon's Nose, Transformed Into a Pregnant Woman Melancholically Walking Her Shadow Amidst Original Ruins*.

We also discover a mystical, provocative Dalí, as scenographer, impassioned by science and, clearly, the Dalí of the final period and his last canvases: *Martyr, Untitled, The Swallowtail* or others, where we see a return to the references of his much-loved masters, Michelangelo and Velasquez.

Portlligat, Púbol and Figueres, three angles of a creative idiosyncrasy, that approach us, show us and explain to us an internationally renowned artist with strong local roots. This book brings us closer to the painter and guides us along some routes that are essential for understanding Dalí's work as a whole. The light, colour, irony and the people... the Empordà region, accompany him and us on this fascinating journey.

MONTSE AGUER TEIXIDOR
Director of the Dalinian Study Centre

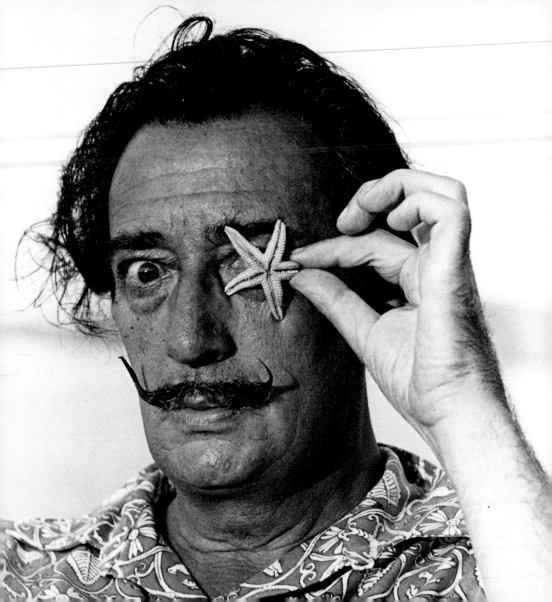

DALÍ'S COUNTRY

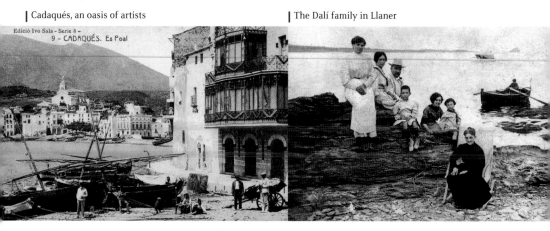

The Empordà. Land of geniuses?

The so-called Dalí Triangle is the geometric result of the joining with straight lines of the towns of Púbol, Cadaqués and Figueres on a map of Catalonia. The figure is undoubtedly based on the Empordà geography, a privileged land that, if the poet Joan Maragall were to be believed, contained the greatest density of the Catalan essence in the world. In 1906 the writer stated, in hyperbolic style, his fascination for this area of land that in those times was associated with republican and federal ideologies and with a love of freedom: three ingredients that did not abound in the Spain of the time.

Besides its ideological ferment – due to its closeness to France from where important enlightened and socialist seeds had been imported – the region, located in the north east of the Iberian Peninsula, was a brilliant and multi-coloured garden of natural marvels. The hiking fever of the period resulted in the rediscovery of this fertile and benign plain, protected by a mountainous amphitheatre. The hikers could hardly believe their eyes: to the north, they came across the crests of the eastern Pyrenees, crowned by the mythical Canigó; to the west, the craggy ranges of Basegoda and the Mare de Déu del Mont; and to the south, the massif of Montgrí, with its profile of a dead bishop, dividing the territory into two counties: the Alt Empordà, extending from the castle to the Pyrenees, and the Baix Empordà, towards the south, with gentler and more rolling hills.

Sheltered by this mountainous profile, the mosaic of the Empordà plain extended to the sea, forming a bright and multi-coloured microcosm, scattered with ancient bell towers, barns and hamlets with steeply sloping streets, through which passed covered traps and flocks of sheep raising clouds of dust. Travellers were enraptured before this miniature Mesopotamia, embellished with the dazzling green of the orchards, groves and humid patches of the marshes.

It is no surprise that such concentrated beauty inebriated the poet Joan Maragall. Like him, other sensitive souls surrendered to the magnificence of these landscapes: the verses of Jacint Verdaguer had transformed the Canigó into a mythological referent, and the prose of Eugeni d'Ors, the head of *noucentisme (the nineteenth-century art movement)*, was at the point of raising a fisherwoman from Cadaqués, Lidia, to the category of being a symbol of the Mediterranean woman.

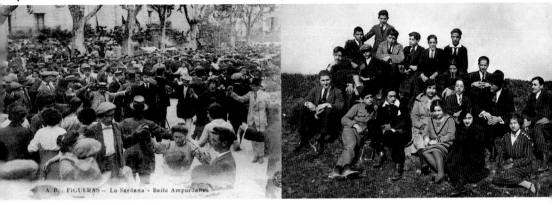

A. B. - FIGUERAS — La Sardana - Baile Ampurdanes

The fantastic scenery was not, however, the only thing that delighted visitors. The most characteristic feature of the country, the *tramuntana* wind, left them speechless. This hurricane-like wind is the result of the meeting of the atmospheric currents of the Atlantic and the air masses that encircle the Golfe du Lion. The clash produces a furious tornado, capable of reaching speeds of over 200 kph, which howl and whistle like the furies of hell. The *tramuntana* rips up massive storm clouds, scatters them and quells any trace of moisture in the air. It forgives nothing and no one. It sweeps up everything and, if it so desires, can derail a goods train. One hundred years ago, guests staying in the Hotel Comerç in Figueres were presented with a couple of bricks to confront the windy days with. If they wanted to walk around the streets without difficulty, they had to put one in each pocket.

Despite the admiration that outsiders expressed for the *tramuntana*, the locals were of another opinion: the wind ruined the crops, stopped the fishermen going out to work and, above all else, was the origin of the adjective *entramuntanat*, a word that burdens all the people of Empordà. Although the adjective does have positive connotations –in reference to the self-confidence, openness and extroverted nature of the area's natives– it is often used to mean madness or perpetual mental instability. Salvador Dalí, in fact, helped in extending this cliché by repeatedly stating that, "The *tramuntana* is responsible for all of us who were born and live in the Empordà being completely crazy". Thanks to this piece of nonsense, the idea started up that the area was a nest of enlightened figures and nutters: a factory of eccentric geniuses.

It is true that, as in other places, there have been people here that do not fit into the most orthodox categories. Some good examples of this are the inventor Narcís Monturiol –creator of the submarine *Ictineu*–; the poet Carles Fages de Climent –a dandy who fired out poisoned epigrams–; the pharmacist Alexandre Deulofeu –who discovered the supposed mathematical cycles of universal history– or the sculptor Artur Novoa –an exquisite marble mason and manufacturer of tombstones. None of them, however, took their extravagance to such superlative extremes as Salvador Dalí did. He exaggerated it with skill until turning it into a substantial element of the theatrical props with which he earned his living.

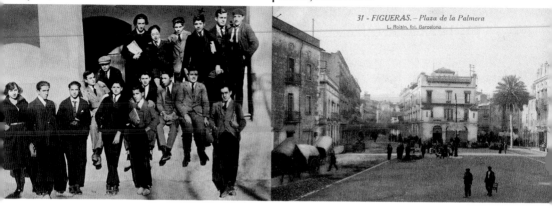

31 - FIGUERAS. — *Plaza de la Palmera*
L. Roisin, fot. Barcelona

We must therefore qualify this supposed influence that the wind has over the character of the people. Nevertheless, the influence of the *tramuntana* on the landscape is unquestionable. Beneath the tumultuous gusts of air, the vertical elegance of the cypresses is bent like an elastic band. Olive and pine trees grow in an uncontrolled and twisted way, the branches coiling around each other with an almost Baroque angst. Amid the furious cries, the *tramuntana* sculpts the rocks and geology of the sloping foothills with the aid of the biting salt that the waves spit out. However, where the atmospheric action is once again more perceptible, more disruptive, is in the special light that the sky acquires during the *tramuntanades*. The firmament, open and clean, turns such a deep blue that it can hurt your eyes. The blue is extended over the earth with an unending voracity, even further than the line where the sea ends. Beneath such a sky, the contours of distant objects become hard, firm and precise, as if they were part of a diorama or three-dimensional film. A sparkling halo runs over the angles of the roofs, the silhouette of the mountains and the patches of vegetation. Everything acquires an anomalous, weird and metaphysical background.

Painting the sharp atmosphere that the *tramuntana* creates is no easy task. Without doubt, Dalí has been its most universal interpreter, although we cannot forget his fellow artists Ramón Reig and Evarist Vallés. The three of them have managed to place on canvas, with an overwhelming naturalness, the spiritual magnitude of this Mediterranean microcosm.

If this setting, from the hand of Dalí, has captivated the public of the world's five continents, it must have something special. The artist knew how to capture the traits of identity of this corner of the world and display them from an unusual point of view. It is true that the painter would not have achieved this feat if his rooting in its landscape had not been sincere, extreme and eternal. At the end of the day, Dalí's passion for his land was no different from that felt by a farmer, a fisherman or a small boy playing in his village square. What we should be grateful to him for is that, during his exile in Europe and America, he took on board all this typical sentimental imagery and, with magnificent wit, made it re-emerge among the triumphant silhouettes of magnates, industrialists and fun-loving millionaires. Unlike them, we can always enjoy the original model.

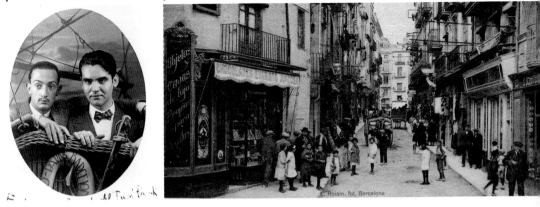

| Dalí and Lorca | The popular Carrer Girona

C. Roisin, fot. Barcelona

A town in expansion

At the beginning of the last century, the economic, cultural and mercantile traffic of the Alt Empordà revolved around Figueres, the capital. The city maintained this status intact until the 50s, when the increasing arrival of large numbers of tourists changed the social customs and infrastructures of the country. In 1900, however, Figueres was the only large town in the county. It had approximately eleven thousand inhabitants – nearly as many as the city of Girona– and its economic activity was based on agriculture and livestock production on its outskirts.

The people of Figueres differed a little from other Catalans in their character. The writer Josep Pla, in an article in 1927 in the newspaper *La Nau*, defined them in this way: "They are a generous people, enthusiastic, lovers of shows, tolerant and not that interested in saving. A person from Figueres loves shouting. He gets agitated, moves his hands, has an animated, expressive face, and needs wide streets to walk down". To argue, get excited about something or be entertained, each social sector had its own venue: the workers went to the Erato, the tradesmen, to the Casino Menestral, and

the gentlemen, to the Sport. The Liceo Figuerense was the town's most select club. It was reserved for the minor aristocrats, those who had a university education and top-ranking military officers.

The military presence in the town went back to the mid-18th century, when the castle of Sant Ferran was built on the Muntanyeta hill. The fortress, of an irregular ground plan, occupied over 32 hectares and had an outer perimeter of 3,120 metres. The central body could house an army of six thousand men. Despite its grandeur, the town had become accustomed to the existence of that useless giant. On sunny Sundays, many families climbed the slope that led to the sentry box of the entrance to take in the majestic panoramic view of the plain. From there they could catch sight of the clusters of villages and groves that extended before the Bay of Roses, between the end of the Rodes range and the foot of the Montgrí mountain.

In those days, Figueres had still not freed itself from the ties that maintained it as an agricultural economy or from its rural customs. As the century advanced, these ties were gradually left behind in order to acquire a more urban sensitivity and tone. Anna María Dalí, in *Nuevas imágenes de Salvador*

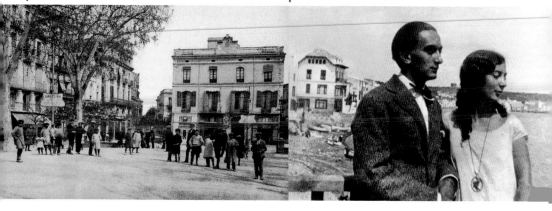

Dalí, illustrates the tension between these two poles in a masterly way: "In 1916, Figueres was an open, enlightened, liberal, extroverted and stately city, with an intellectual concern that ennobled it, despite the fact that, every Thursday, with the hustle and bustle of the market, it became peasant again. The streets and squares became outdoor trading posts and they bought and sold poultry, cereals, vegetables and livestock. The colour and movement of the purple and red caps filled it with life because the farmers from all around the county came to the gathering with the expected racket and commotion. A racket and commotion that contrasted with the atmosphere on Sundays, when the Figueres people, elegantly dressed, met in the shade of the plane trees on the Rambla to listen to the music of the San Quintín Regiment who played waltzes by Strauss and Franz Lehar, while the officers of the General Staff, dressed up in sky blue silk sashes and belts with their breasts full of golden medals, courted the young ladies. This was the time that Figueres appeared as a city from an operetta".

The Sunday soundtrack was not limited to just the waltzes however. From the 19th century onwards, thanks to the musician and composer Pep Ventura,

creator of the modern Sardana dance, the town had become the main centre for this beautiful "federal dance". The Empordà *coblas*, or musical bands, tired of the howling and shrieking of the wind, had decided to oppose it with the sweet and penetrating sound of the tenora, a type of oboe. On public holidays, when the farmers and townspeople put on their glad rags, the Sardana dance was ever-present. The music was sometimes played by the San Quintín military band under the direction of the sergeant and maestro Llovet. In the spring of 1925, when the poet Federico García Lorca visited the Dalí family, he was presented with a Sardana recital as an act of eternal friendship.

The music, racket and hustle and bustle was also present on the first of May, when the population threw themselves into the Fairs and Festivals of the Santa Creu, or Holy Cross, a break in the routine for the Figueres people. An impressive multitude arrived in Figueres from all parts of the county. The cafes and boarding houses could not cope with the demand and the top artists performed in the theatres. The donkey fair meant a continuous traffic of livestock and carriages, while the fruit markets, with their symphony of fragrances and vibrant colours, occupied all the

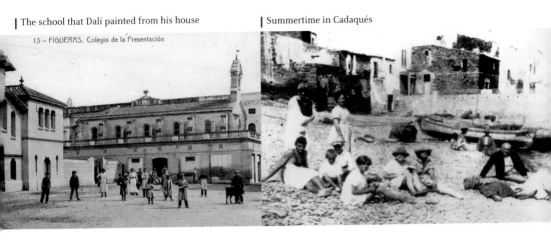

| The school that Dalí painted from his house | Summertime in Cadaqués |

13 – FIGUERAS. Colegio de la Presentación

squares. The stallholders set themselves up, with their stalls and trestles, in what is today the Plaça de la Palmera, from where flowed the sweet aroma of the hot fritters. Sometimes, over the incessant hubbub of the attractions, the cries of moustached smooth-tongued salesmen could be heard, standing on a table, preaching the benefits of African snake ointments.

This astonishing scene, logically, seduced Dalí. According to him, the fairs provided the streets with a "Hellenic" flavour. It is no surprise that these crowded festivals stimulated his creativity as a young man. The artist designed posters, organised exhibitions and recorded these treasure-filled days in cheerful, self-assured and rather naïve paintings. His eye captured the agitated movement around the circus big top, the popular festivals in the surrounding area – between agaves and balloons rising towards the clouds – and at night, the magical and colourful explosion of the firework displays.

With or without the fair, the unmistakeable heart of social life in Figueres was the Rambla, the central avenue flanked by two rows of plane trees. This rectangular avenue, framed by two small squares and surrounded by a belt of cafes, restaurants and bookshops, was the best place to get the grey matter moving. This

is shown by the fact that Dalí, duly supplied with gin-fizz, sat at one of the tables of the Emporium café to write the script for *Un chien andalou*.

A large crowd – unimaginable today – moved up and down the Rambla unceasingly. These avenues had strict timetables and codes of conduct for each social class. Jaume Miravitlles, in the compilation *Més gent que he conegut*, recalls these rules in this way: "In the transitional moments, when two or more classes coincided in the Rambla, a geographical separation was voluntarily established that was so well defined it appeared as if it was the Parliament of a modern democracy: right, centre and left, with perfectly defined areas. If by chance someone went to the Rambla at a time that was not "theirs", or crossed the frontiers of their area, they would come across a world as unknown as the Moon or Venus". Amongst the mass assembled on the Rambla were always the more popular characters: the gipsy shoe-shine boys, La Manciana – an ancient chestnut seller –, the cobbler of Ordis – the man who forecast the movements of the tramuntana with the aid of a reed – or Poll and Puça – two barrel organ players that the painter, in a fit of nostalgia, would end up paying homage to in his Theatre-Museum.

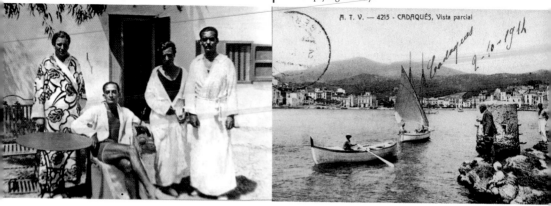

A. T. V. — 4215 - CADAQUÉS, Vista parcial

Human activity in the Rambla was never-ending at any time of day or night, even when the moon shone over the plane trees. During the First World War, a faction of Francophiles, led by the intellectual Gabriel Alomar, often frequented it to argue through to the early hours of the morning. Their arguments caused so much racket that the neighbours, from their windows, pleaded with them to shut up.

The Rambla became more elegant in 1918, when it underwent a relentless reform, under the direction of the architect Ricard Giralt Casadesús. The avenue was freed of an entire block of houses in the upper square; the ends were made longer and the stone kerbs, flights of steps, flower beds and lighting were added. To complete the dignification of the Rambla, a monument was erected in honour of Narcís Monturiol, inventor and the town's favourite son, crowned by a magnificent sculpture by Enric Casanovas.

Another characteristic element of the avenue was the large circular clock, visible on the facade of the Soler watchmaker's, no longer in existence today. It would be bold to suggest that the enormous face of this clock, which lit up at night, is the origin in the famous melting clocks. However, in 1920, the painter is portrayed in his early diaries reading in the Rambla, while, "the hands of the clock lazily showed the passing of time". Essentially speaking, a melting clock is nothing more than a clock that stretches out, yawns and becomes flaccid again, tired of the parsimony with which the hours pass.

Joking aside, it is worth pointing out that Dalí read books in an open-air space, something that could be considered as a positive symptom of the cultural high spirits of the time. In 1918 in Figueres, the first stone had been laid of its future Public Library and besides the lively and very dynamic associations it also had prestigious schools. One of the main ones was the Institut, founded in 1839, which had amongst its teaching staff figures such as the writer Gabriel Alomar or the painter Juan Núñez. The latter had a decisive influence on Dalí. In fact, his lessons were given to several generations of creative talents. The seeds cultivated by Núñez are currently on show in the rooms of the Empordà Museum. A visit here is essential in order to demonstrate that Dalí did not appear like a shining stray comet, but that he was surrounded by a constellation of artists.

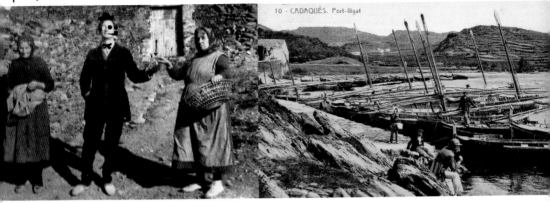

10 - CADAQUÉS. Port-lligat

The little fishermen's village

The notary Salvador Dalí Cusí was born in Cadaqués in 1872. As if it were a genetic inheritance engraved in his DNA, he passed on to his son the passion for that world of white houses that caress the water. Happiness for the future painter consisted of losing himself in the labyrinth of streets that rise and fall, with raking cobblestones, beneath the enormous mass of the church of Santa María. If you add to the setting the lead-coloured sea and small orchards, speckled with blossoming almond trees and bright orange trees, you will get "an eternal and living landscape, but perfect", as the poet Federico García Lorca described it.

The scenic perfection of the spot was surely related to its historic isolation, since it had evolved on the margins of the rest of the county, separated by the Rodes range. The highest point of this mountainous barrier is the Pení, a solid peak of 613 metres. On the other side of this natural wall –behind which the sun disappears each evening– the inhabitants of Cadaqués had developed their very own customs, spoke a unique variant of Catalan and did not consider themselves as citizens of Empordà in particu-

lar. The particular idiosyncrasy of this microcosm would begin to crack in 1908, with the construction, at the Coll de Perafita, of a road connecting the village with the plain. Despite the new road network, going to Figueres from Cadaqués would continue being an odyssey: the journey by carriage took between five and six hours, and when the slopes were very steep, the passengers would even get down from the carts to lighten the burden of the mules.

Until the construction of the road, the inhabitants of the village had survived thanks to their merchant fleet. They had extended out to sea. Their boats went to and from Genoa, Civitavecchia, Naples and Cuba. Whole generations of skippers and sailors knew Africa and South America without having set foot in Figueres. On the wharf of Portdogué the traffic was continuous: pilot's boats, schooners and brigs, in full sail, dropped anchor full of clothes, ceramics, salt and wood for making the barrels with which the wine and salted fish was exported.

Fishing was a fundamental activity for daily subsistence. On nights without moonlight, the boats set off to fish with lit torches and, if they were lucky, would return in the morning loaded with sardines,

anchovies, mackerels and horse mackerels. Part of the catch was salted in the village canning industry, and the rest was transported by rowing boat to the Roses fish market. The seabed, as well as providing food, also guarded other treasures such as the coral reefs hidden in the rocky parts of the bay. Obtaining it was made possible by the presence of the Kontos, a group of divers of Greek lineage who risked their lives each time they descended quite a few metres in search of the red gold.

Besides the fruits of the sea, the population lived from growing olive trees that produced top-quality oil. Cultivating vines until the phylloxera epidemic wiped out all the stocks in 1883 complemented this activity. The dry stone walls are silent witnesses to this disaster, extraordinary walls that border the mountains of the area, like steps erected by a race of extinct Cyclops.

With such a precarious economy, almost a survival economy, the homes of the local people were very humble. They had no running water and the women had to go and fetch it from the Font Vella twice a day. They carried it in shiny green jars on their heads with an amazing elegance. Apart from carrying the jars of water or the bundles of wood that the men left at the entrance to the village, the women also took on the burden of the stigma of superstition. Belief in witchcraft was still alive and deep-rooted in the village, as it was in other small villages in the Empordà region. Malicious remarks about the most eccentric young women in the community gave them supernatural powers and made them responsible for extraordinary events.

To shrug off the bad luck and tedium, every 20th of January the entire village set off on a procession to the hermitage of Sant Sebastià. The church, hanging the middle of the Pení mountain and facing the rising sun, was the setting for a mass celebration. Whole families travelled up to the spot, with their baskets full of food and *porrones*, typical drinking vessels, of wine. The climb between the olive groves was hard going but the atmosphere was relaxed: The *cobla* of musicians played *pasodobles* behind the parish priest who carried the Baroque figure of the saint.

When the procession reached the hermitage, there were rounds of dancing and singing. Ever-present at the festival were the so-called *patacades*, satirical and witty compositions dedicated to the authorities

and popular figures of the time. The families got the food ready in the shade of the pine trees: the aroma of rosemary blended in with that of the grilled meat while the shells of the sea urchins gradually piled up on the plates. This seafarer's food, typical in the coldest months, is one of the favourite dishes of the people of Cadaqués.

The hospitable and friendly atmosphere, which always inundated these festive acts, must have been crucial in the quick conversion of this small community into a hive of artists. The inventor Narcís Monturiol was one of the first to experience it. In 1856, the artist fled from political persecution and was welcomed generously in Cadaqués. Monturiol, who promoted the plastic arts, earned his livelihood by painting portraits to order.

The authentic artistic revolution of the colony took place at the beginning of the 20th century, when the numerous Pitxot family bought a piece of land on the peninsula of Es Sortell, close to the beach of Sa Conca. Under the enterprising leadership of Antonia Gironés, mother of seven restless and highly gifted children, a magnificent house was built, which immediately became an art sanctuary. The Pitxot dynasty had painters: the madcap Ramón, friend of Picasso; gardeners, Pepito; musicians, Luis and Ricardo; opera singers, María Gay, and poets, Eduardo Marquina. Due to their open character, a complete entourage of intellectuals and artists were able to enjoy the qualities of Cadaqués. The fame of the place spread like a wine stain on a tablecloth and, as the years went by, it attracted figures as universal as Marcel Duchamp, Man Ray or Merce Cunningham.

As well as being key figures in the cosmopolitanism of the town, the Pitxot family were also a key element in Dalí's artistic training. There is a revealing anecdote on this matter: The family used to put a grand piano on their boat. They moored the boat beneath the craggy edges of Es Sortell and, in formal dress, gave moonlit concerts. At the beginning of his mature stage, Dalí would recreate some of these evening soirées on the canvas entitled *Atmospheric Skull Sodomizing a Grand Piano* (1934). Observing the painting subjectively, we can sense a hidden, and deserved, homage to this ever so enterprising family dynasty.

The charm of the Empordanet region

If we take the road that goes from Figueres to La Bisbal, the C-252, we cross over from Alt Empordà to Baix Empordà in a peaceful and gentle way, without any fits and starts. Leaving behind Viladamat, just in front of the grey side of Montgrí, the beautiful dominions of the Empordanet region begin, a curvilinear plain that spreads before the sea and which ends, in the southwest, with the green, wooded wall of the Gavarres. Compared to the neighbouring county, the tones of this scenery are more placid, more harmonious and delicate. Perhaps the added touch of softness it contains is due to the dimensions of the territory. Its size, comfortable and accessible, make it a paradise of a classical nature.

The Baix Empordà, however, like other gardens of Eden, has not been able to resist the temptation of the forbidden fruit. The mark of human arrogance is clear for all to see on the coastal strip where, close to the salty spray, there are piles of concrete beehives, burrows and termite mounds. This urban oppression, this overwhelming overcrowding, is balanced out, fortunately, by the series of villages that are discretely spread through the interior of the countryside. They are attractive and old little villages, built from hundreds-of-years-old stone that take on the colour of honey. In their streets, on the land and sown fields that surround them pulsates the sturdy inheritance of the peasantry.

On the map, the capital of the Empordanet region is La Bisbal, but in reality, it is far from being the centre that draws together the leisure, social and economic interests of the county. The magnetism of other places such as Torroella de Montgrí, Sant Feliu de Guíxols or Palafrugell, active towns with their own life and personality, pass and exceed La Bisbal by a long chalk.

This is the case of Palamós, a seaside town where, even today, the life of the fishermen continues to have an everlasting value. Palamós, like Cadaqués, can also claim to be a meeting point between the coarseness of the seamen and the most modern and elegant cosmopolitanism. It is no surprise, then, that between 1930 and 1935, the town was one of the favourite destinations of Gala and Salvador Dalí. At that time, Dalí's artistic career had hardly begun, but the couple, with the nose for publicity that characterised them, knew very clearly where they had to be.

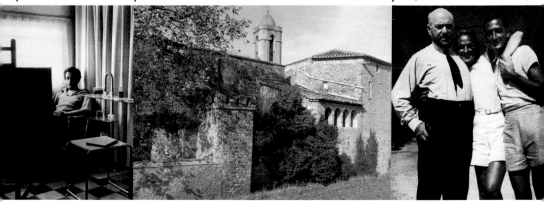

During their stays in Palamós, the Dalís would visit Mas Juny, a beautiful farmhouse located on the beach of Castell. In those times, the house was owned by the painter Josep Maria Sert and the Georgian princess Roussy Mdivani. The residence had been converted into a lavish centre that played host to celebrities such as Luchino Visconti, Coco Chanel or Marlene Dietrich. After the Civil War, the farmhouse would change owners. The artist would return to visit the place in the early fifties, and it even had a fisherman's hut on the beach of Castell –with a strange leaning door– if he wanted to paint undisturbed.

The visits to the Empordanet region, a small footnote in the couple's expansive social life, contrasts with the enclave that the Dalí's would choose, in the twilight of their lives, as their centre of spiritual retreat. Then they would choose a corner far from the select, mundane and bustling spirits. They turned their backs on the coastal strip and settled inland.

This new strategic and biographical movement is dated in 1969, when Dalí secretly initiated the paperwork for the purchase of the castle of Púbol. The little village, a neighbourhood of La Pera, would be revealed as the perfect oasis for the privacy that Gala had been demanding from the artist for a long time. Thanks to the painter's wife, the castle, the old fortress of the Corbera family, was rehabilitated and it recovered part of its feudal splendour. Gala, with her enigmatic presence, brought an aristocratic essence to Púbol, a surreal and post-modern fragrance that would leave a mark on the village forever.

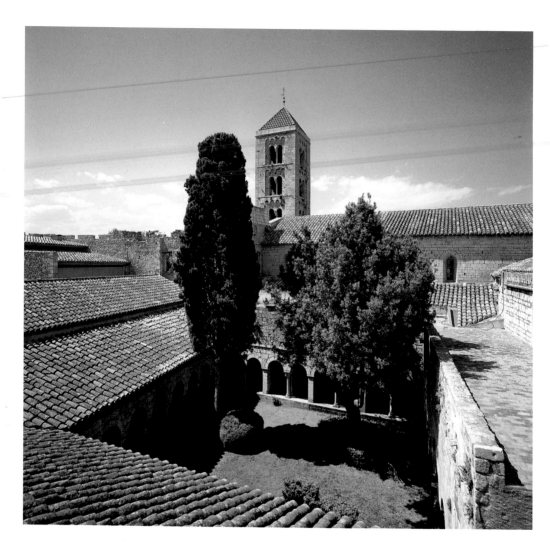

Vilabertran was one of the gardens of Eden where Dalí learnt to paint as a child.

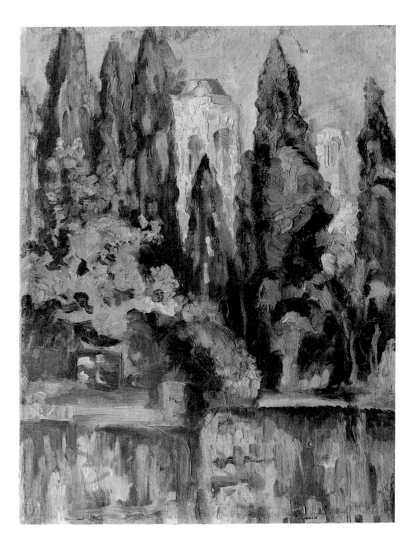

Church and abbey of Vilabertran, 1918-19. Private collection, Barcelona

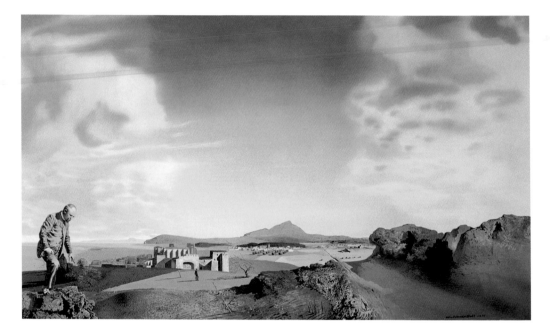

The Pharmacist of Empordà in Search of Absolutely Nothing, 1936
Museum Folkwang, Essen. Germany

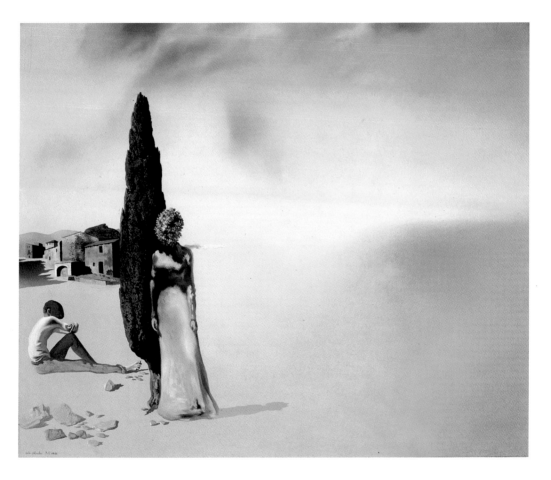

NECROPHILIC SPRINGTIME, 1936. Private collection

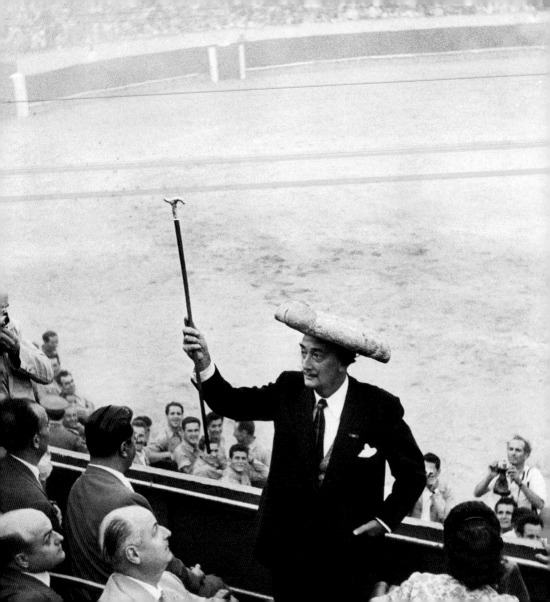

FIRST ANGLE:
FIGUERES

The apotheosis of the Theatre-Museum

A RAINY AFTERNOON IN SUMMER

Long before Andy Warhol's milk teeth came out, Salvador Dalí had already given a great acting performance from his public appearances. The artist's taste for pantomime would culminate in the last great masterpiece of his lifetime: the conversion of a theatre into a totally surrealist object; a labyrinth that would contain the synthesis of his thought and work, where the public would be able to fully explore Dalinian cosmogony.

Nobody can deny that the project fulfilled all that he set out to do. On any visit to the Theatre-Museum, the surprises come one after the other. The spectators do not get a second to take in breath. They receive contradictory flashes and sensations, while they are assailed by images as unforgettable as *The Spectre of Sex Appeal* (1932), *Portrait of Gala with Two Lamb Chops Balanced on Her Shoulder* (1933), *The Bread Basket* (1945) or *Galatea of the Spheres* (1952). Without realising, visitors pass through the memory, obsessions and spectres of an unrepeatable author.

Dalí designed his project on the old Municipal Theatre of Figueres. The building, erected in 1849 according to the design by the architect Josep Roca Bros, was in ruins, a crumbling skeleton. Nobody was interested in it at all. The Civil War had put paid to its days of glory: nationalist soldiers had set fire to it in February 1939 and only the charred walls remained standing.

The theatre began its resurrection twenty years after the flames had claimed it. Everything took place in a relaxed way: one summer afternoon, after a drizzly period, Dalí noticed broken edged and damaged brickwork. Accompanied by the painter Joaquín Bech de Careda, he visited the ruins. He was impressed by the structure of the premises. He took with him a few pieces of lime that had fallen from the walls, and suggested using the space for musical shows. The idea

remained in the air, but nobody could imagine that the artist would become obsessed with the building. The turning point came in may 1961, when the painter told the mayor of Figueres, Ramón Guardiola, and his trusted photographer, Melitó Casals, that his ambition was to build an extraordinary museum in this place.

The choice of the site, according to the artist, was down to different sentimental reasons: to start with, the property was opposite the church of Sant Pere, where he had been baptised, and formed part of his adolescent erotic fantasies. Secondly, his first public exhibition had been held in the theatre's halls, in December 1918, in a show shared with the painters Josep Bonaterra Gras and Josep Montoriol Puig: everything fitted.

Enthused by this vision, Dalí began formulating ideas to transform this ruined carcass into a centre that could be visited. Despite the hasty desires of the genius, he would have to wait for a decade before his dream began to come true. The reason for the delay was the unending hard bargaining between the Figueres City Council and Fine Arts Council, which did not wish to become financially involved in the project. The mistrust from Madrid lay in the concept of the museum argued by the artist: Dalí did not want any original work in the space, only photographic reproductions of the paintings. "People will not be disappointed in the museum", insisted the author, "The photos have an advantage: they are better than the original work. They will be disappointed when they see the originals." Of course, Dalí ended up by conceding and agreed to loan original paintings to the museum. With the conflict resolved, reform work on the theatre began on the 13th of October 1970.

The next month, the artist kept to his word and deposited a part of the ceiling mural of the Rest Room ceiling. The piece, named the *Palace of the Wind*, symbolised a final ode to the land of his birth. Overlooking the setting are two giant figures of Gala and Dalí dancing

a Sardana over the Empordà. Their bodies, seen in a foreshortened way, are full of open draws from which sprout gold coins. The interpretation of the work is very simple: "Gala and I will pour a rain of gold over the spectators. Over the Empordá plain falls the gold that I have been accumulating throughout my life". The prediction certainly came true: thousands of visitors would visit the museum year after year.

It is worth noting that the Palace of the Wind also represented an allegory of Dalí's private home. For this reason, in a small room on the right-hand side, a space was built as a bedroom with a bed in the form of a seashell, ownership of which is attributed to La Castiglioni, one of Napoleon III's favourites. In the room on the left-hand side a painting studio was recreated, where different works of art, his own and others', extol the power of eternal femininity. Due to the handling of this concept, the artist would become a type of surreal hotelkeeper who invited us to taste the paranoid marvels of his home and country.

AGAINST THE EMPIRE OF THE RIGHT ANGLE

The silhouette of the Theatre-Museum has become an international pop icon. Its geodesic cupola is unmistakeable. Who knows whether Dalí, on designing it, wanted to recover an old idea he himself had come up with in 1931, when he wanted to create a surrealist amusement park for Charles and Marie-Laure de Noailles? The park had to include an empty sphere to give the public the feeling of returning to the womb.

The architect Emilio Pérez Piñero was entrusted to add the crowning touch to the Theatre-Museum. He did it with a steel and glass structure, inspired by the work of the North American designer Samuel Fuller. According to Dalí, the cupola was the emblem of monarchic architecture and he liked to compare it with the Parthenon of Athens, "a symbol of the republic, that is always filled with spiders' webs and swallow shit". Dalí would also use the cupola to attack the buildings of Le Corbusier, in order to anticipate the end of the dominion of the right angle and forecast the arrival of the kingdom of the perfect sphere.

Construction work on the cupola began in January 1973. Photographs of the process travelled around the world, although the images taken by photographers were not solely focused on this part of the museum. The interventions on the old stalls, such as the inclusion of the Rainy Cadillac, the arrival of the opulent statue by Ernst Fuchs –which had to go over the bonnet of the car– or the unloading of Gala's yellow boat above a very high column of tyres, aroused comments and speculation of all kinds.

Dalí, in collaboration with the painter Antoni Pitxot –member of the talented dynasty from Cadaqués– also designed four grotesque monsters that recalled the playful spirit of the creatures decorating the Italian gardens of Bomarzo. Located on the central windows of the courtyard, they are the best example of the Catalan saying "Everything is used". They are built on a base of stones from Cadaqués, gargoyles from the church of Sant Pere, old draws from the Town Hall, the fountain of a public park, bits of branches from trees in the Rambla, snails' shells and the head of a marine creature that appeared dead in Cap de Creus.

We come across another of the great Dalinian creations in the Mae West Room. Between 1934 and 1935, the painter retouched a photo of the North American actress and converted it into the room of an apartment. This time the artist wanted to go even further and designed the facial room in three dimensions. An amazing combination of gigantic wigs, pointillist paintings, nasal orifices with logs stuck to them and a sofa of lips made the project credible and achieved an amusing and original result.

Dalí did not limit himself to the facade and interiors of the building. He also transformed the area around the property with his magical touch and installed a

type of foretaste of the monumental collection in the open air. Before the doors of the Theatre-Museum is the sculptural series dedicated to the Catalan philosopher Francesc Pujols, a thinker who, like Dalí, was capable of mixing metaphysical abstractions with the most ironical humour. The intellectual, whose body is represented by the trunk of an olive tree, holds a golden hydrogen atom. Maybe, who knows, because philosophy often tries to understand volatile and gaseous concepts?

The homage to Pujols is not the only singular item in the square. There are also the colonnades of tractor tyres that watch over the plaster sculpture of the painter Ernest Meissonier – two of whose pieces are on exhibition in the museum –; a magnificent obelisk made from televisions by the artist Volf Vostel; a display with the face of a giant surrounded by eggshells; a stone fountain crowned by another hydrogen atom and a sculpture in honour of Newton on the steps that go down to the Carrer de la Jonquera.

Dalí had other ambitious designs to adorn the square. These projects included purchasing the Romaguera house, where the cafes are in the square and which Dalí wanted to join to the museum by means of a raised bridge. Unfortunately they were unable to carry out these proposals due to financial questions.

A LIVING AND CHANGING BUILDING

The official opening of the Theatre-Museum was held on the 28th of September 1974. The triumphal apotheosis included a mass parade with a convoy made up of musical bands, dwarves and theatrical bigheads, *trabucaires*, that fired off salvos; vintage cars, disorientated hippies and an elephant called Jazmine.

Having the building ready for this date had been no easy task. Dalí's collaborators worked against the clock. They only had three months to complete the pending works. As the deadline day approached, it became clear that the artist had not loaned the museum enough pieces of work and that many more would be needed, a fact that conditioned to a large extent the setting-up of several rooms. Only ten days before the official opening, Dalí made a new delivery of paintings and his secretary, Captain Peter Moore, left some on temporary loan. The new canvases were hung at a dizzy speed.

This is a revealing anecdote. It shows that the artist did not see the space as something dead, mummified and unalterable. For him the museum was a *work in progress* in which there could be improvisation, removing some items or adding others according to the circumstances.

The most obvious demonstration of this concept was the annexing to the Theatre-Museum of the neighbouring Casa Gorgot, built on the 12th of October 1983. The whole building included a tower – today the Torre Galatea – that formed part of the old medieval walls of the city. The painter's interest in the estate went back a long way. He had visited it while the theatre was being remodelled and wanted a hotel owner from Figueres to open a restaurant there where only the artist's favourite dishes could be served.

As soon as the building had been bought, the "Dalinisation" of the facade was practically immediate. The *pa de crostons*, crouton breads, a typical product of the county, were placed all over the walls throughout 1984, while the building was fitted out as a home for the painter. The serialised accumulation of loaves of bread aimed to achieve a similar effect to that of the Casa de las Conchas, in Salamanca, or of the Italian Palazzo dei Diamanti. This idea, which Dalí had tried to use in a house in Cadaqués in the mid-fifties, was a response to the artist's worship for this food. When someone criticised him for being photographed with a *pa de crostons* on his head, Dalí replied, "All my acts respond to ideas I had as a child. For example,

the bread I often put on my head is a hat with which I introduced myself at home when I was six. I emptied a *pa de crostons*, this Catalan loaf of bread with three crust, and I put it on my head". From the distant memories of his childhood, the loaves of bread have leapt onto the facade of his new house.

To complete the setting, the painter chose some gigantic eggs like those decorating his house in Portlligat. It was quite a logical choice: Dalí had used eggs in many paintings, performances, actions and sculptures. Besides the mythological connotations of the food, it is worth mentioning that Empordà eggs, above all the yellow ones, are very famous indeed for their quality and are much more expensive in the markets than those from other regions.

The Torre Galatea became the painter's final residence. Due to a small intervention, the building was connected by a door with the Theatre-Museum, the artist's last worldly love. Dalí's passion for this enormous monument made him decide, when he was almost at death's door, to turn it into his final place of rest. According to his wishes, he was buried there with full honours on the 25th of January 1989. The final decision of the genius, to become an integrated part of this great ready-made museum, was totally in line with his personality.

After the painter's death, the Gala-Dalí Foundation bought a building adjoining the Torre Galatea. This spot has been transformed into an independent space, which since 2001 has housed the magnificent jewels of the Owen Cheatham collection, designed by the artist. The sculptures in pearls, rubies, sapphires, gold and diamonds are the perfect culmination of that quixotic idea of Dalí, thought up one rainy summer afternoon, while the reflection of the bell tower of Sant Pere became blurred over the wet ground full of puddles.

The streets of art

Rocked to sleep by Monturiol

Dalí can be described in many adjectives, but above all others there is one that fits him perfectly: *figuerense*, meaning a native of Figueres. Outsiders may find this a little strange but this is, in fact, the case. Just as we associate the Beatles with Liverpool or Elvis Presley with Memphis, Figueres, the artist's birthplace, shaped the microcosm of his childhood and youth, provided him with landscapes, friendships and experiences that he would distil by means of his own creative filters. The first *urbs* of the painter was not Madrid, or Paris, or New York, or Barcelona. It should not surprise us that, in the latter years of his life, the artist returned to his private Eden with the idea of recovering all the memories he could and then crystallise them, in his language, in the Dalí Theatre-Museum.

In contrast to what is usually believed, the painter's childhood was not very traumatic. Son of one of the city's wealthier families, he was brought up with a good education and in an atmosphere that was pleasant, supportive and easy-going for him. The artist was born on the 11th of May 1904, in the mezzanine of number 20 Carrer Monturiol (today number 6) and was given the name of Salvador Felip Jacint Dalí Domènech. His father was the notary Salvador Dalí Cusí, from Cadaqués, an expansive man, and republican with a tempestuous character, and his mother Felipa Domènech Ferrés, from Barcelona, a cultured woman from whom the young boy may have inherited the sensitivity towards the arts.

The couple had had another son in 1901, Salvador Gal Anselm, who only lived for twenty-two months. The artist included this lost brother in his mythological biography, as can be read in the volume entitled *The Secret Life of Salvador Dalí*. In his own made-up fiction, the author prolongs the life of his brother until the age of seven, giving him a wonderful precociousness and using him to accuse his parents of

"subconscious crime" for having baptised him with the same name. Dalí was always brilliant at manipulating details.

In real life, the artist had a younger sister, Anna María, who was born in 1908. Like other members of the family, she served as a model for his early paintings. The painter's gallery of figures also included the nanny of the house, Llucia Gispert, an old lady who always complained about the wrinkles that the young man added to her portrait. In 1910 the family was joined by María Anna Ferrés, his maternal grandmother, and her daughter, Dalí's aunt, Caterina, who moved into the flat above. In 1921, after the sudden death of the painter's mother, his father the notary eventually married Caterina.

Carrer Monturiol, where the Dalí family lived, starts from the small square below the Rambla and was at that time one of the most elegant arteries running through the city of Figueres. Just above the gallery of the flat was a garden full of exuberant chestnut trees, which formed part of the stately home of the Marchioness de la Torre. The notary has set up the office on the ground floor of the family home, very close to the Sport, the gentlemen's club where each night he met with a group of friends and had heated political arguments.

In the 70s, the artists renamed Carrer Monturiol with the name of "street of the geniuses" because, apart from the inventor and himself, also born there was the man of literature, Carlos Fages de Climent, the musician Albert Cotó and the sculptor Artur Novoa. The street also brought together other neighbours touched by the artistic *daimon*, or gift, such as the drawing teacher Juan Núñez, or the historian Alexandre Delofeu. The latter knew the painter from childhood: "The notary Dalí had his office opposite my father's chemist's. We played together as children. One day, Dalí me told me he adored the God Buddha and that he had an altar. 'Come over and I'll show it to you' he said. We went up to his house. He and his sister took me to a room where, over a small table, there was an image of Buddha. They did some ceremonies and then we went off to play again".

In 1912 the Dalí family moved house from number 20 Carrer Monturiol to number 24, on the upper floor of a new building (today number 10), designed by the architect Josep Azemar. The flat faced the Plaça de la Palmera, the spot where the spring fairs of Santa Creu were held. The small square also housed the weekly market: every Thursday, alongside the slender silhouette of the palm tree, the stalls were chock-a-block with cauliflowers from Vilabertran, turnips from Capmany and all the other delicacies grown in the county's orchards.

The notary once again set up his office on the ground floor of the new building. In 1925, he would play host to the poet Federico García Lorca, who gave a public reading of the drama *Mariana Pineda*, at that time unpublished, to a reduced coterie of Empordà intellectuals. Who knows whether, by some mysterious law of compensation, while his father occupied the ground floor, Dalí took over the high part of the building and transferred his private paradise to the flat roof? Of the two utility rooms in the house, he converted one into his studio. The pages of *Secret Life* state that he had been sitting inside while he drew, with the water up to his waist.

Besides the utility room, the terrace roof had another big attraction: the scenery that could be seen from it. According to the painter, "The view of the city, extended at my feet, served to stimulate the unlimited ambition of my supreme imagination. The entire panorama from the Bay of Roses seemed to obey me and depend on my stare". On the opposite side of the Plaça de la Palmera, Dalí could see the Garatge Soler and, to his left, the bell tower of the school of French nuns (the origin of one of the double Dalinian images: the girl-bell skipping). In the background of the built-up

area stood out a part of the Golf de Roses, the houses of the Palau-saverdera and the mountains of Sant Pere de Rodes.

This vision, relaxed and idyllic, has been expressed to perfection in the painting *The Girl of Figueres* (1926), in which the painter included an advertisement of the garage, with the word *Ford* over a blue background. In the seventies, Dalí pointed out that this symbol was a precursor of pop art, "due to the fact of standing out from such a classical composition, it caused an incredible scandal in the city." If this is the case it must have been one of the first aesthetic shocks that the author gave to the town's bourgeois consciences.

JUAN NUÑEZ'S FAVOURITE STUDENT

That Dalí was predestined to cultivate the fine arts seems to be an unarguable fact. He was obsessed with drawing from an early age. Already at the age of six he drew ducks and geese on a wooden table with a spoon or fork. In 1916, Pepito Pitxot, amazed by the young man's progress, advised the notary that he needed to find a drawing teacher for him. In the autumn of the same year, Dalí enrolled at the Municipal Drawing School, run by the Andalusian Juan Núñez Fernández. Núñez had a very solid academic training, was an excellent engraver and also gave classes as a secondary school teacher in the Figueres Institute, where the young man ended up enrolling. Between one place and the other Núñez would be Dalí's mentor for six years.

The Drawing School, at Carrer Tints (now number 20), was an oasis of freedom that compensated Dalí for the effort made in the subjects he found more difficult (such as mathematics and other "stupidities"). Anna María Dalí remembers her brother's passion in this way: "His love for Mr. Núñez's lessons was so strong that on one afternoon when it rained down cats and dogs he nevertheless attended class. He was the only student who never missed a class. Mr Núñez said, 'I believe he would come even if chick peas were falling from the sky'".

Núñez's students were used to copying plaster statues –a frenzied gladiator, an agonised Laocoonte– while a neighbouring violinist accompanied them playing, month after month, the same sonatas. Salvador coincided in the art classes with Ramón Reig and Mariá Baig, future artists like him. He also established a relationship with Carme Roget, his first amorous adventure. The classes obviously had their moments of hacha-cha. When his classmates wanted to make Dalí nervous, they let out some grasshoppers in the class. The leaps of the insect caused the artist to scream in panic. These creatures, with horrific connotations, would later be incorporated into his iconography in oil paintings such as *The Great Masturbator* (1929).

Núñez had the fame of being a demanding teacher. With a quick flash of his pencil, he would correct the mistakes in his students' exercises, but when he saw Dalí's works, he would stop and smile. The boy had taken the work so seriously that, at the end of the first academic year, in 1917, he received an honorary diploma from the Mayor of Figueres, Marià Pujolar. The notary, extremely excited, organised an exhibition of the drawings in the sitting room of their home and to celebrate his son's success invited his friends to come and eat sea urchins on the terrace.

For Dalí, Núñez was a revelation. "He is the man I have respected most and from who I have learnt most in my life", he stated. The academic would soon open up the doors of his house and the young man lugged his canvases there so that the maestro could give him his opinion. In the winter of 1920, aware of the boy's qualities, Núñez advised Dalí to give up everything in order to devote himself to painting. His words were emphatic: "When I see your father I'll tell him that you won't do anything stupid. To hell with the books!" The teacher's recommendations greatly irritated the

whole family. Finally, however, bursting with pride, they ended up giving in and agreeing that he would go to Madrid to study for being a university drawing professor. When Salvador found out how much a Spanish drawing professor at the time earned, he exclaimed, "But my salary will be that of a carabineer!" He was mistaken. He would have a much better salary. A salary of "Avida Dollars".

ALWAYS WITH A WATCHFUL EYE

For such an ambitious draughtsman, the utility room soon became too small. By the age of seventeen, Dalí already had a studio in two large rooms of the family home that faced Carrer Monturiol. According to eye-witnesses the cards and canvases piled up in there, decorated with splendid skies, seas and fields. The studio was frequented by a group of young gypsies who he used as models. If necessary, they sang and played guitar, resulting in a cheerful and stimulating racket.

If the progress made by the young man in the pictorial sphere was notable, his performance in other academic matters was irregular. As a student, Dalí made a *tour* of the different academies in the city: the Marist school, now disappeared, the college of the Fossos – La Salle – and the local Institute. In general he was bored by the monotonous explanations of the teaching staff and used the classrooms to ignite the fuse of his imagination. In class his mind wandered and he daydreamt even if the physical conditions were not favourable. Faced with such disinterest, neither numbers nor words could do anything.

One afternoon in January 1920, in the middle of a raging fever, the artist discovered double images in a classroom of the Marists. They were like ghosts that were hiding in every corner. All that was required was how to make them materialise: "I had a temperature and felt my burning lips", he wrote. "Leaning over the varnished desk, I saw the chipped plasterwork and scratches of the walls and composed allegorical figures and effigies with my imagination. There below the table was a crack that looked like a ballerina. Higher up, a Roman soldier". The young man, then, experienced in the flesh the crazy superimposition of images: an optical illusion that, later on, would be reproduced on his canvases with the characteristic personality of a calligraphic brushstroke.

Outside the classroom, Dalí kept open a watchful eye: he took out a notepad, sharpened a small pencil and, with the expertise of an entomologist, put onto paper the silhouettes of the city's typical characters. A classmate of his, the painter Marià Baig, recalls that while they were studying in the Institute he always sketched an old man walking along the street on crutches. Who knows if this crippled walker was the origin of the Dalinian symbol relating to impotence that the painter used left, right and centre?

The sketches by the bright young man were not restricted to the human figure. When it was the time to do nature classes, Figueres had a privileged observatory to become entranced by the changes in light and atmospheric conditions. It was enough to sit down on the Banc del General, opposite the castle of Sant Ferran, and take in the magnificent view of the Empordà plain. The natural elements took charge of adding the rest. Dalí spent many afternoons there, accompanied by Joan Xirau and Ramón Reig. They loved the hallucinatory effects of the setting sun. While the crickets sang amongst the agaves, the three friends shared aloud the emotion of discovering lilac sunlight, the surprising shape of a cloud, and the redness of the houses and the blue strip of sea. The mountains in the background were painted pink while the streets of the city, at their feet, were tinged with poetry and charm. They were the streets of art. A treasure chest within reach of whoever considered them with a fresh and candid look, with an open spirit full of hope.

The magic of the outlying area

IMPRESSIONIST CALLING

Dalí had discovered impressionism in June 1916. It was during his stay in Molí de la Torre, a country house on the outskirts of Figueres, alongside the Manol river. The estate was the property of the opera singer María Gay, an artist from the Pichot clan. When the carriage dropped him off in front of the house, the young Salvador could never imagine that he was about to have an aesthetic experience that would drive him crazy.

Inside the house, shining like a wonderful lantern, the paintings of Ramón Pichot were awaiting him. Pichot was a bearded, cheerful bohemian and a personal friend of Picasso. The dining room walls of the Molí house, where the boy had breakfast every morning, were festooned with oil paintings and engravings by the old patriarch. Years later, Dalí would recognise in *Secret Life* the impact that these pieces had on him: "Those breakfasts were my discovery of French impressionism, the school of painting that has had the deepest impression on me in my life, because it represented my first contact with an anti-academic and revolutionary aesthetic theory".

The son of Figueres had moved to the Pichot family home to spend one month there with his box of oils in his baggage. His hosts provided him with a well-lit room, full of sacks of wheat and corncobs, to use as his studio. According to the painter, one day he started working on an old, dismantled door. He drew cherries applying the colour directly from the tube. The result was greatly admired by the inhabitants of the house and the farm workers who lived in the surrounding area. One of them pointed out that he had forgotten to draw the stalks. Dalí then picked up some cherries, ate them and stuck the stalks onto the wood. He was not satisfied with this. He also added live worms to his work.

Pepito Pichot was so amazed by the results that he promised to recommend to the notary to get a drawing teacher for his son. Salvador refused the offer, saying that he was an impressionist painter who did not need any kind of lesson. If the anecdote is true, we could say that it was an *avant la lettre* version of his famous refusal in 1926, when he refused to be examined in the School of Fine Arts of Madrid because he thought that the board that had to test him was incompetent.

ORCHARDS, PONDS AND WAVES

Dalí's identification with the Empordà region, in contrast to what is commonly believed, was not limited to the towns of Figueres and Cadaqués. His sensitivity is the result of his exhaustive knowledge of the peculiarities of a region that he had travelled through from top to bottom, with the persistence of a cartographer. Very different towns in the county: Llançá and Vilafant, Castelló d'Empúries and Borrassà, Llers and Vila-Sacra all bore witness to his visits and contributed to shaping his personal perception of the countryside.

Having become a restless explorer, the painter focused his early discoveries on the outskirts of Figueres, reflected in his early canvases and prose. These works reverberate with the echoes of dirty, muddy streets, of silvery olive groves and bell towers gilded by the sun's rays, of white cottages with moss-covered roofs, of cows with sad expressions and agitated geese fleeing from strangers. Between the cadmium-coloured paths and the bright blue sea line, Dalí's creative talent gradually evolves, nourished by the power of nature surrounding him. We have proof of this fascination in his teenage diaries. They are the most privileged source for understanding his daily world, free of the masks and legends that he would later invent.

It is astonishing to see how the artist notes down the world he inhabits with an extraordinary documental precision. One example: on the 24th of May 1920, the painter goes out for afternoon tea with the family and friends to some woods close to Figueres.

The outing is described in this way: "The wheat fields spread alongside the path, full of thistles. The wheatears sway to and fro in the wind and the fields sway like golden waves. Everything reverberates with light and the powerful earth shows its fertile nature. The poppies embroider the fields with red stains and the orchards spread into the distance, with fruit trees laden with green fruit, their rooftops of tomato plants beginning to ripen. The irrigation ditches water the roots of the cabbages and vegetables, and the spring flowers are responsible for decorating the railings of the wells with exquisite taste. The sparrows sing and the swallows fly level with the sky. We continue along a path lined with daisies and yellow flowers alongside the track. With my aunt we speak about communism with great spirituality. We leave behind some railway huts. All of them with their allotment, their well, their dog and their baby with frightened eyes, the hens and the ducks, stretching their necks and looking skywards, and the woman sitting by the front door, weaving. In one of the huts we leave a jar of water and carry on until reaching the wood. This wood is leafy and full of vegetation. The trees grow, as they like, without any order at all. The flowers and the broom adorn the tapestry formed by the moist moss and the water lilies raise their yellow and purple heads and look towards the sparkling sky which is hidden behind the foliage".

In this fragment, of a lyrical and exultant tone, we capture how the painter's desire to capture the landscape with a maniacal exactitude vibrates. When Dalí matures he will achieve his goal thanks to the minute detail of hyperrealism. He will discard the impressionist tools and romantic exaltation of his early days to convert the Empordà plain into a magnificent and enigmatic backdrop, a kind of cyclorama where there are projected double images, outlandish architectures, hallucinations and hunchbacked figures. In the somnambulist reformulation of his country, the artist includes the most basic animal life: donkeys and swallows, grasshoppers and billy goats, sea urchins and ants, which will invade the paintings conferred with cryptic or sinister connotations.

None of this can be seen from his early creative efforts which are the extract of a lyrical self, pantheistic and inflamed, that is still unaware of the oneiric richness of surrealism. They are the result of the fondness he feels for the charming little villages on the outskirts of Figueres, such as Vilabertran. This village, famous for its Romanesque monastery, surrounded by cypresses and magnificent orchards, is a common place of pilgrimage for the Dalí family, where they meet up with the family of his classmate Ramón Reig. To get to Vilabertran the Dalí family must have walked for a quarter of an hour along lush, tree-lined paths. The walk always provides a pleasant reward: the sight of the Romanesque bell tower reflected in the pond next the abbey.

This pond, currently protected by fencing that makes it impossible to reach, fulfils the functions of a small romantic garden with ducks swimming and a rowing boat for those wishing to cross its placid surface. Salvador is excited by the pond and expresses it in several pieces of work. The spot fascinates him so much that, quite a few decades later, he will try to reproduce a similar one alongside his house in Portlligat. He will even dream of converting the original pond into a setting for the film called *The Meat Cart*, a piece of madness that included an old lady dressed as a bullfighter drowning in water up to her waist with a French omelette on top of her shaven head. Each time the omelette slipped off her head and into the water, a Portuguese man replaces it with another. None of these ideas were ever realised, but they show that Vilabertran had an impact on the artist's psychological baggage.

Along the same lines, the Bay of Roses remained engraved on the retina of the painter. His diaries as a young man show a Dalí in full telluric communion

with the geography of Roses. On the 28th of May 1920, Dalí the notary travels to Roses for reasons of work. Ramón Reig and his son take advantage of the trip to make notes about the nature. Dalí wrote this about the day: "The oppressive sun shone and we climbed up to the Greek castle! You could feel the earth vibrating and the big and small lizards hid from us as we passed, scurrying between the gorse and the rocks. From the ruined walls a great immensity of blues and light dominated. Below, the rocks, the virginally white spray, the green seabed. On the horizon, the mountains on the other side of the coast: Begur, the Illes Medes, L'Escala, almost fading away with the brightness of the sky. Everything was a melody of fine colourations. The swallows swooped past and crossed the clouds. I have felt the desire to fly and throw myself into the void!"

After these laudatory lines, which could be attributed to any fisherman from the bay, it is not surprising that the artist would recall Roses when he lived in the United States. The murals he produced in 1942 in the dining room of Helena Rubinstein's flat expressed an unmistakeable replica of the beach of Roses, seasoned with elements of a mythological nature: over the golden sand move the spectres of some horsemen, while in the water we witness the struggle between a warrior and a mermaid-like creature; two marvellous figures that, if they existed in real life, would end up as parts of the props in a theme park, deprived of any titanic breath.

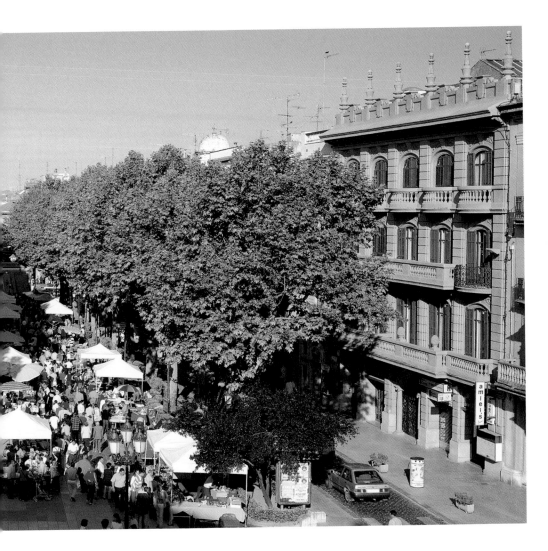

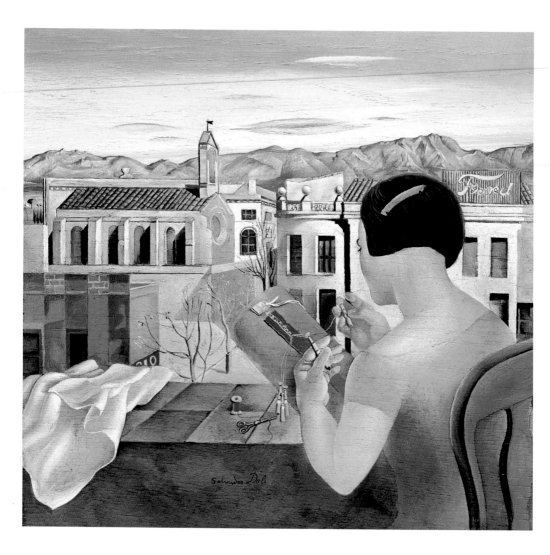

THE GIRL OF FIGUERES, c. 1926. Fundació Gala-Salvador Dalí, Figueres

Indifferent to the street noise, Dalí wrote *Un chien andalou* on the terraces of the bars.

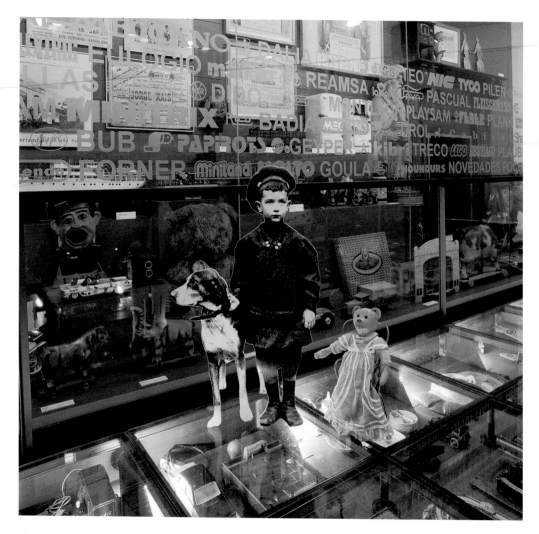

The Toy Museum recalls Dalí as a child thanks to photographs, drawings and
a charming teddy bear that Federico García Lorca called Don Osito Marquina.

48

The Museum of Empordà preserves the work of masters and contemporaries of the painter from Figueres, alongside works that had an influence on him.

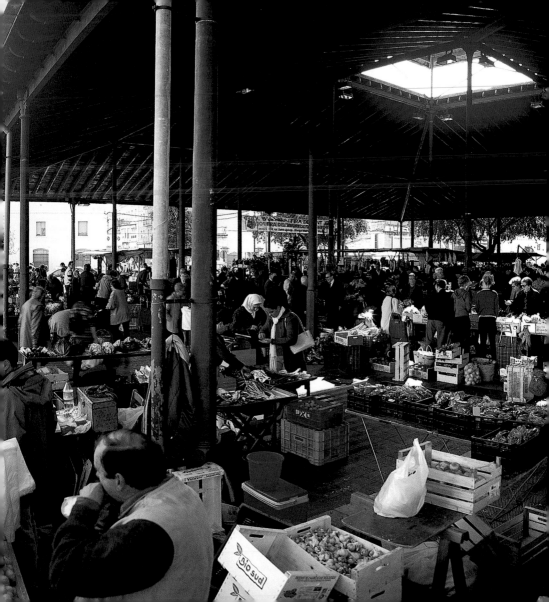

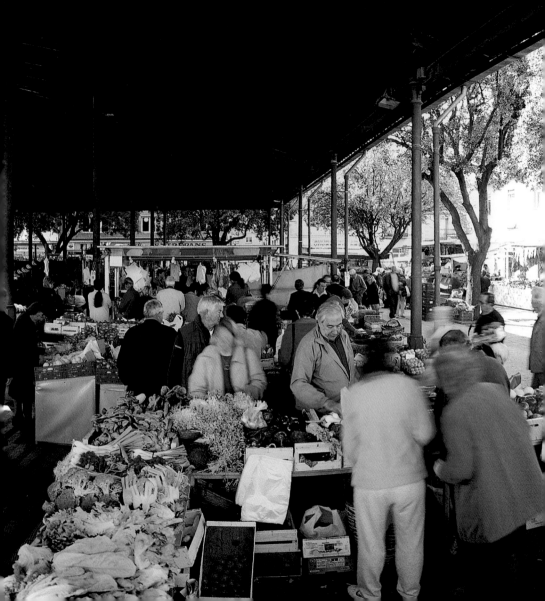

Every Thursday, with the market stalls in a state of turmoil, Figueres became a peasant stronghold. Poultry, cattle and fruit and vegetables unfolded into a symphony of colours speckled by the reds and purples of the farmers' berets. The Plaça del Gra still plays host to this festival of aromas, light and noise.

Going shopping in the late afternoon or relaxing looking at the shop windows was a common activity for Anna Maria and Salvador Dalí. Since those days, the commercial drive of Figueres has not decreased. Some shops still preserve that immutable charm that makes them genuine.

"THE PAINTING I LIKE MOST IN THE WORLD IS THE ONE OF A BELL TOWER BY VERMEER DE DELFT. AND SEEING AS I FEEL GREAT JEALOUSY FOR VERMEER, BECAUSE I CANNOT PAINT AS WELL AS HIM, I ALWAYS MASTURBATED ON THE ROOFTOP OF MY HOUSE WHEN THE SUN WAS SETTING AND THE BELLS OF THE BELL TOWER RANG IN FIGUERES"

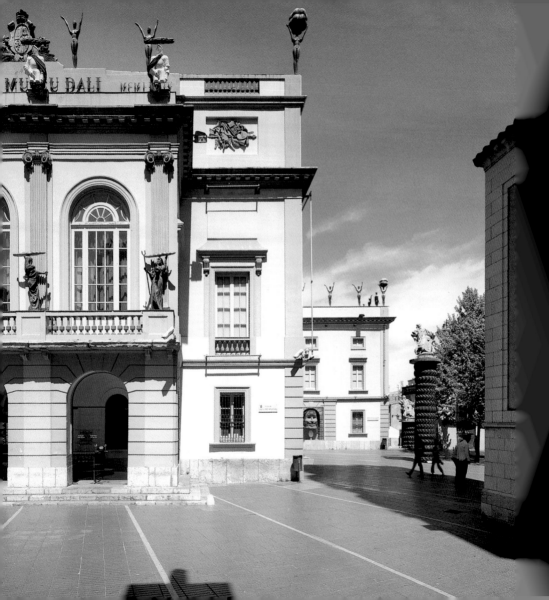

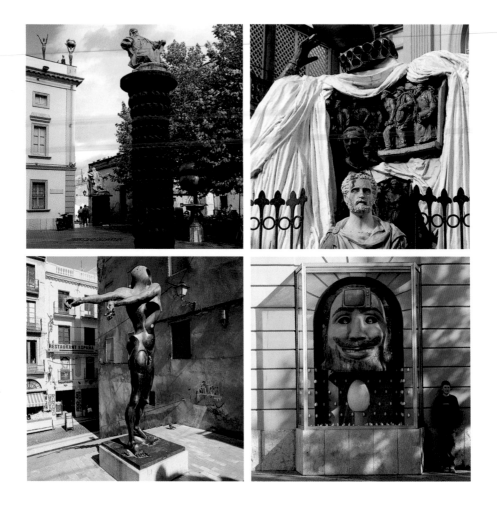

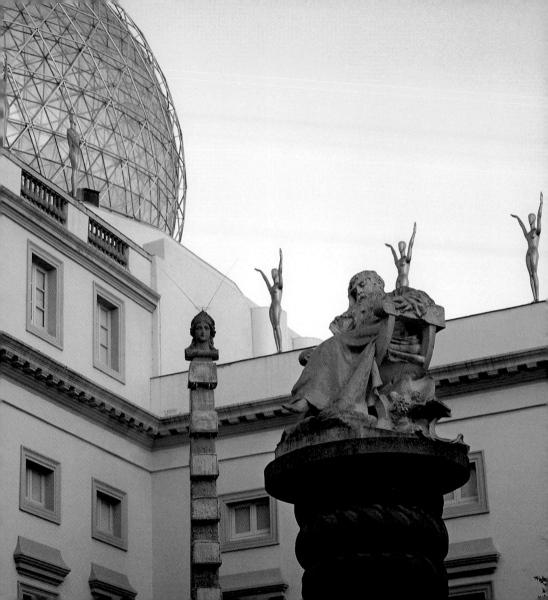

Dalí built his museum over the charred remains of the city's old Main Theatre. His idea was to convert it into a centre of western and European spirituality. According to the painter, anyone that wanted to be up to date with the latest cultural advances would have to come to Figueres, taste the typical sweet *botifarra* sausage and then immediately see the world through the hallucinatory magma of the museum. Philosophers such as Francesc Pujols, scientists such as Newton and painters such as Meissonier were represented in the museum's courtyard, as homage to all the thinkers that had an influence on the construction of Dalinian cosmogony. The eggs of Empordà and the peasant bread are the natural food with which the artist was fed from his childhood onwards.

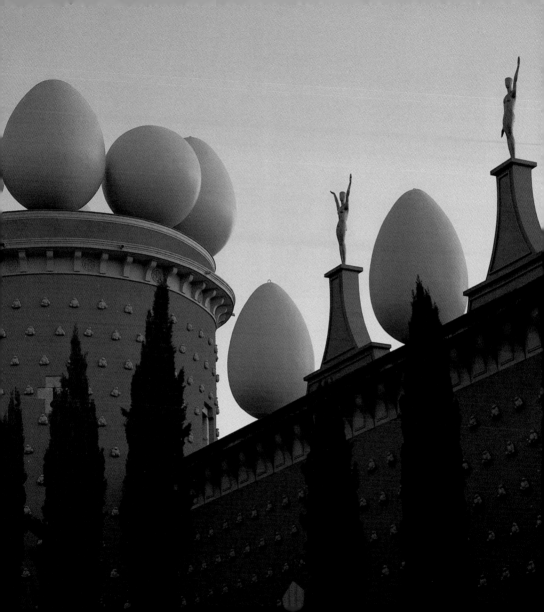

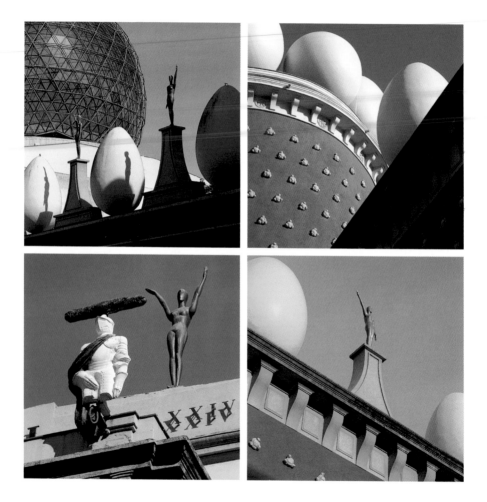

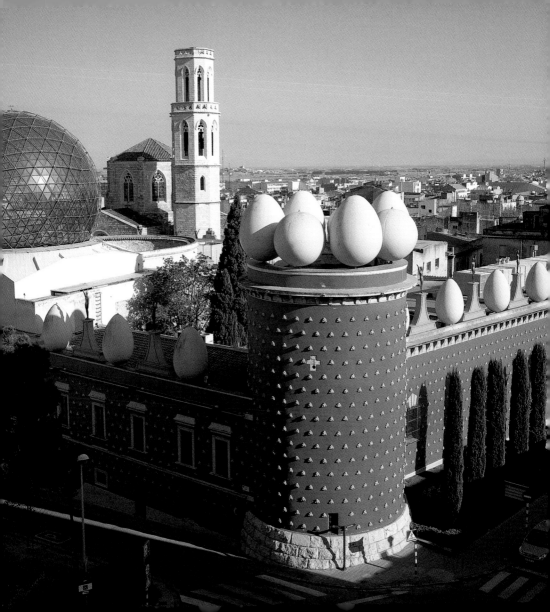

"BREAD HAS BEEN ONE OF THE OLDEST SUBJECTS OF FETISHISM AND OBSESSIONS IN MY WORK, THE NUMBER ONE, THE ONE TO WHICH I HAVE BEEN MOST FAITHFUL"

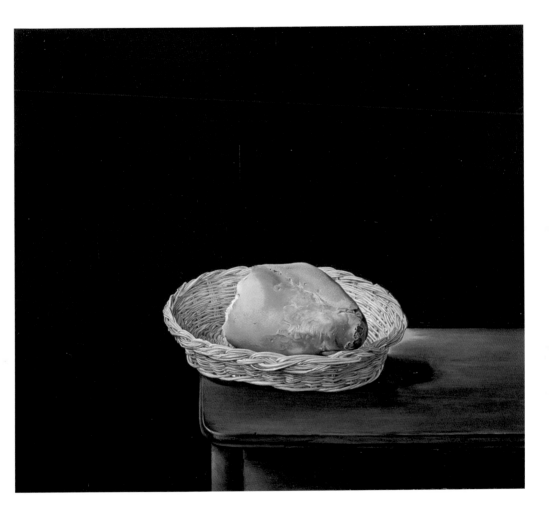

BASKET OF BREAD, 1945. Dalí Theatre-Museum, Figueres

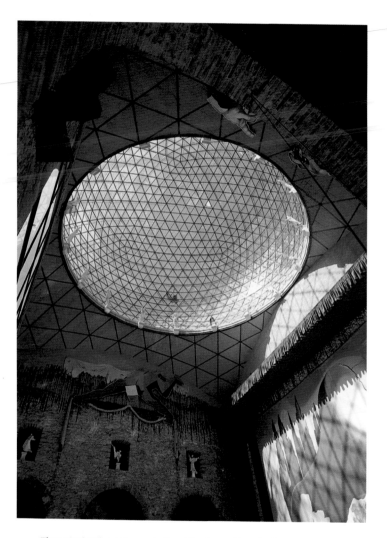

The reticulated cupola was designed by the architect Emilio Pérez Piñero.
When the tramontana wind blows, its futuristic mesh sparkles like a diamond.

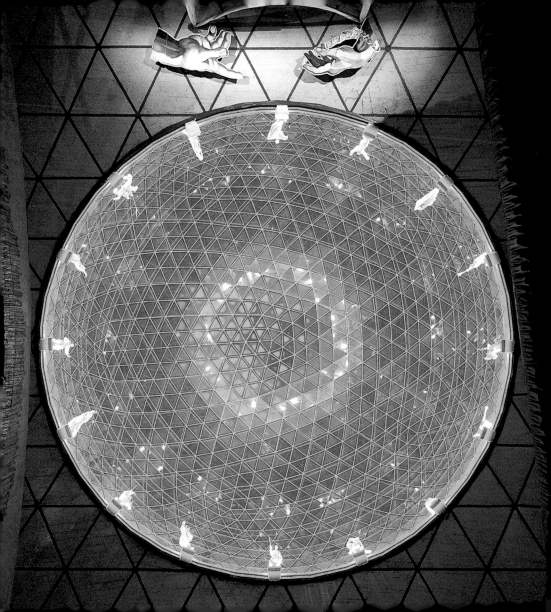

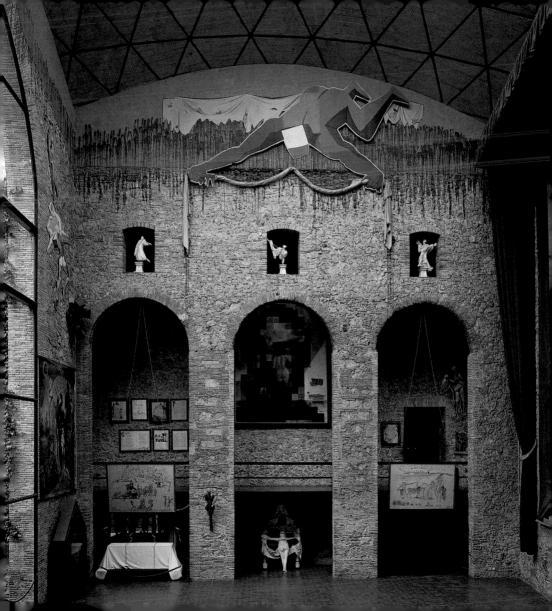

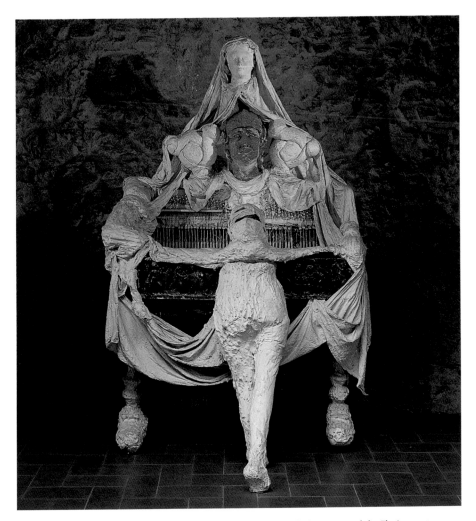

Amadeu Torres and Teresa Marquès, known as "el Poll i la Puça" (the Louse and the Flea), were two bohemians from Figueres who filled the streets with music. Dalí rescued the duet's barrel organ and turned it into a surrealist object. The sculptural assembly occupies a place of honour in the museum.

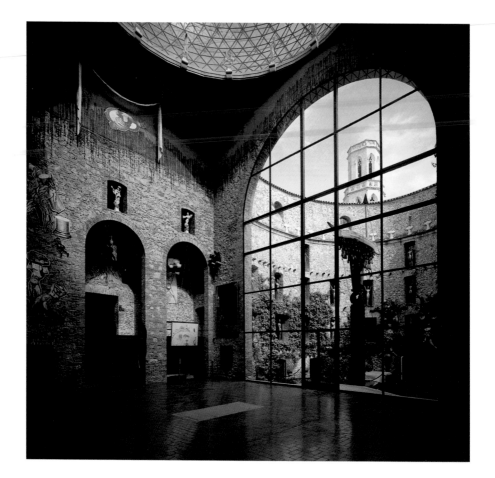

The stage of the old theatre was turned into an inner courtyard, covered by the reticulated section of the geodesic cupola. This beautiful space is the heart, the authentic centre of the Dalinian complex, from where artistic, conceptual and philosophical energy is pumped out to the rest of the building. The sum of the crazy architecture, unusual installations and overwhelming decorations recall the dreams of an exalted playwright.

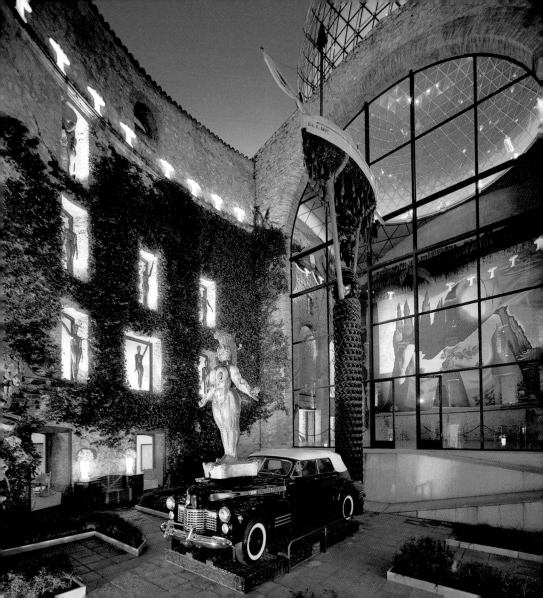

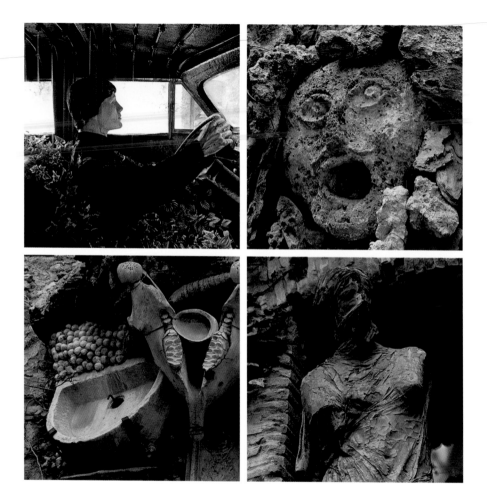

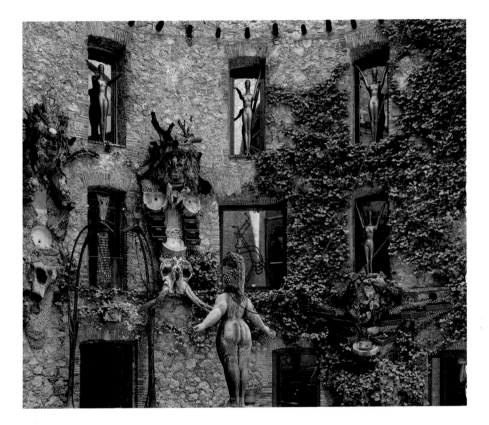

Gala's boat rises gloriously towards the clouds, supported
by a column of tyres. Beneath the bow, the rainy Cadillac moves
forward, overlooked by the opulent sculpture of Queen Esther.
The walls of the setting contain hieroglyphics of the modern age:
fluorescent washbasins and hieratic mannequins, stone monsters,
modernist lampposts and animal skeletons. The ivy climbs along
the walls with the skill of a romantic alpinist.

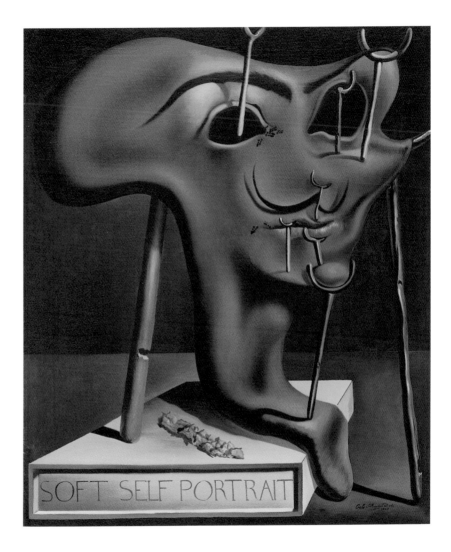

Soft Self-portrait with Grilled Bacon, 1941. Dalí Theatre-Museum, Figueres

The embalmed body of Salvador Dalí i Domènech, the incommensurable artist and Marquis of Púbol, rests in the crypt fitted out beneath the cupola. The holed body of a giant watches over the eternal rest of its creator. It cannot avoid a tear, in the shape of a cypress, from sliding down its cheek.

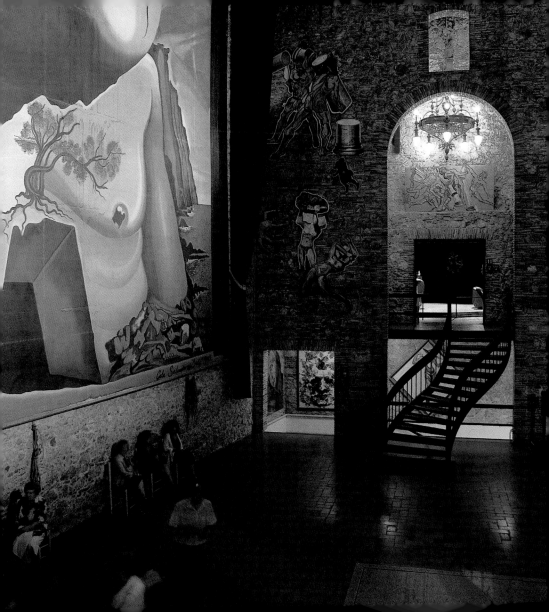

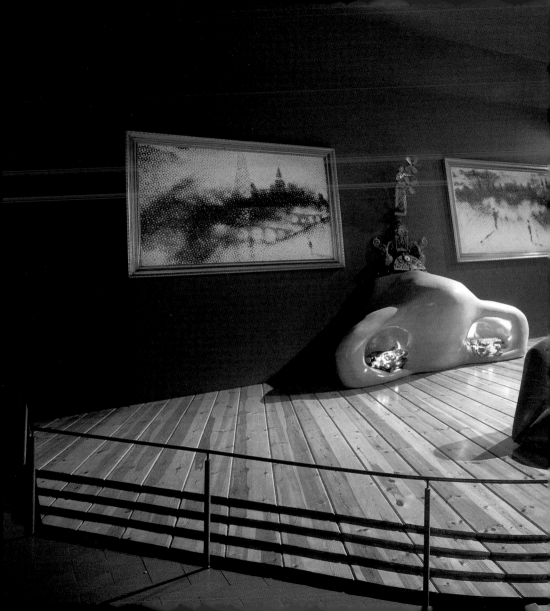

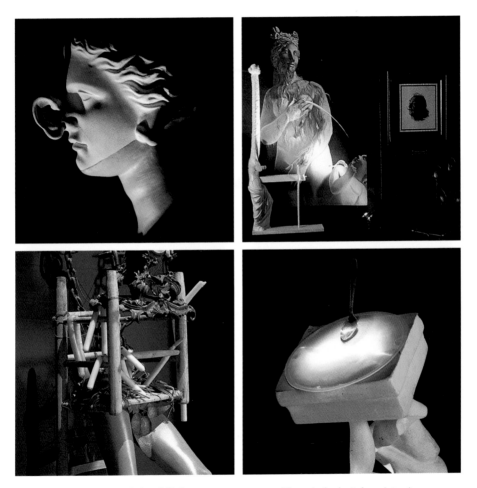

Dalí gave Mae West's face full plastic surgery treatment. The artist broke it down into pieces to transform it into a living room of Dadaist proportions. The space is a cocktail shaker full of ironic references to pop art, hyperrealism and to the assemblies of Marcel Duchamp.

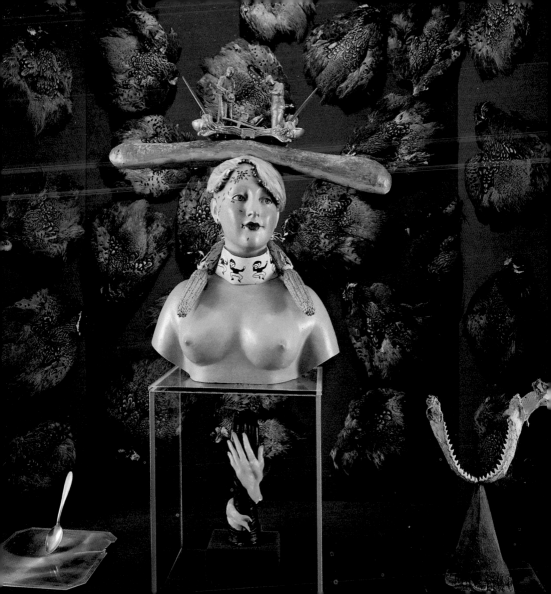

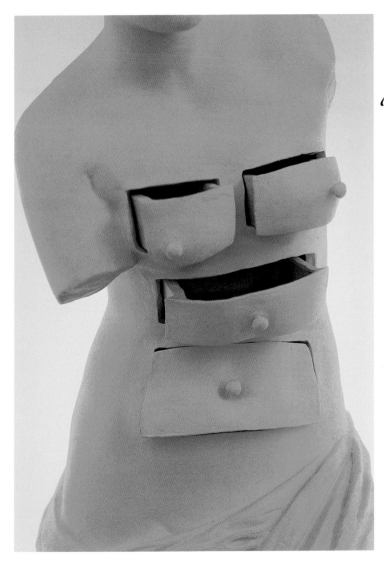

"I WANT MY MUSEUM TO BE LIKE A SINGLE BLOCK, A LABYRINTH, A GREAT SURREALIST OBJECT. IT WILL BE A TOTALLY THEATRICAL MUSEUM. THE PEOPLE WHO COME TO SEE IT WILL LEAVE WITH THE SENSATION OF HAVING HAD A THEATRICAL DREAM"

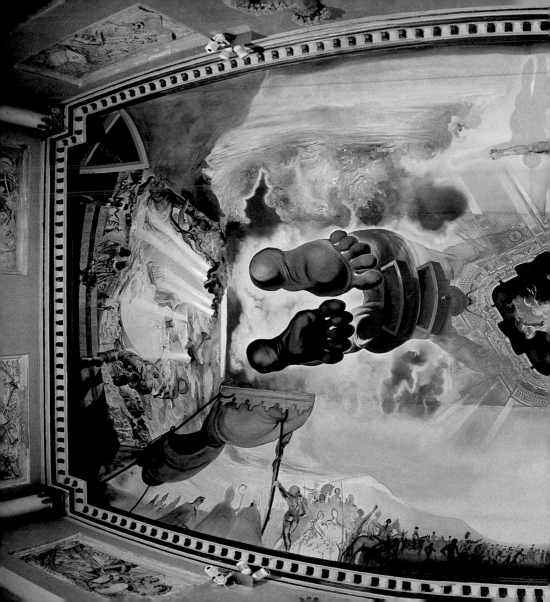

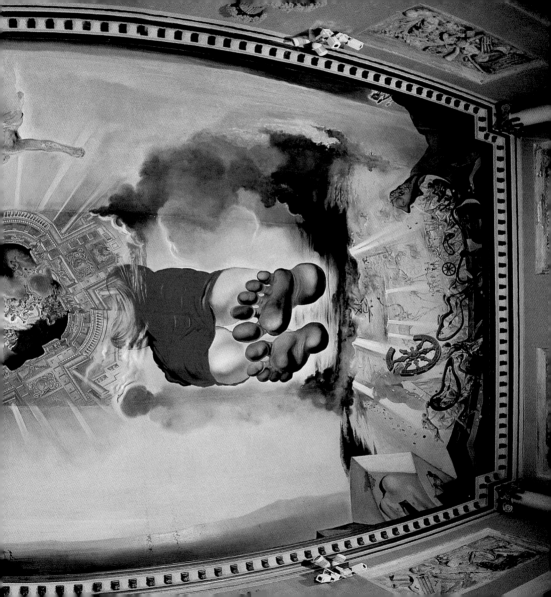

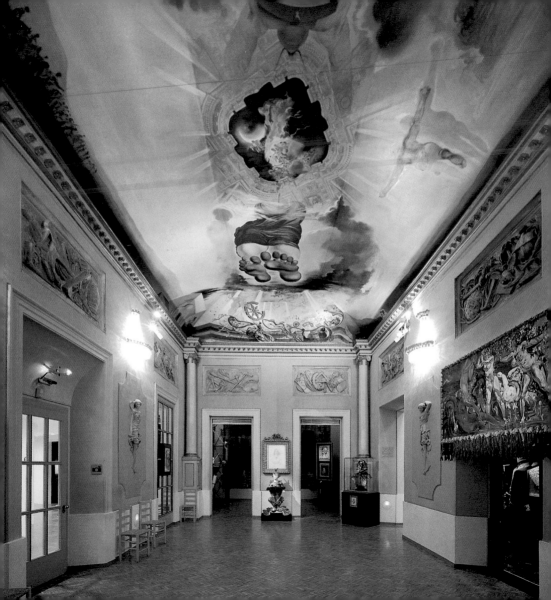

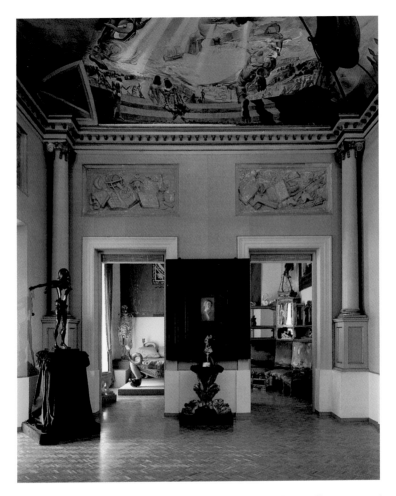

Gala and Dalí, converted into giants, dance a Sardana over the sky of Empordà. Drawers project from their bodies, from which a shower of gold pours over the county. The ceiling of the *Palau del Vent* room (Palace of Wind) is the artist's declaration of love to the land that was his birthplace. The most representative elements of his iconography – from the *Great Masturbator* to the soft clocks – are paraded along the fresco with the same glamour as film stars

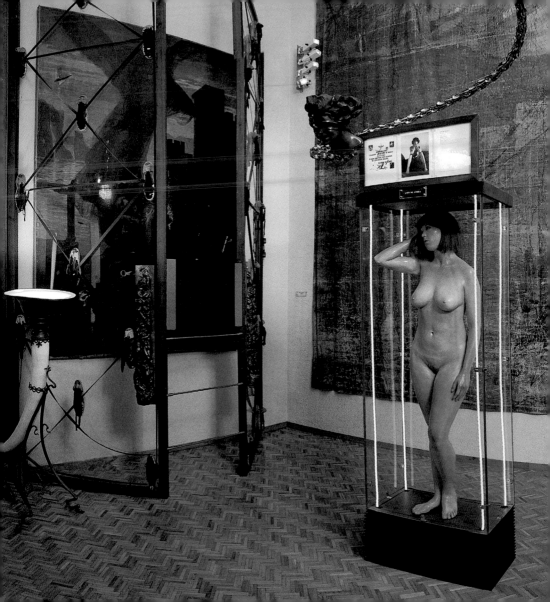

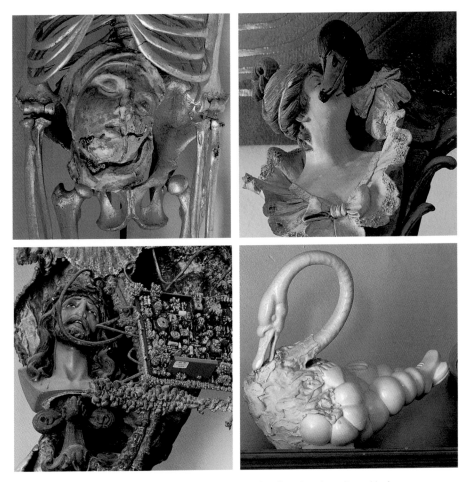

The annexed rooms of the *Palau del Vent* symbolise the painter's studio and bedroom.
Both areas are designed so that the visitors, calmly and patiently, discover treasures,
enigmas and visual tricks that will go unnoticed by tourists in more of a hurry.

93

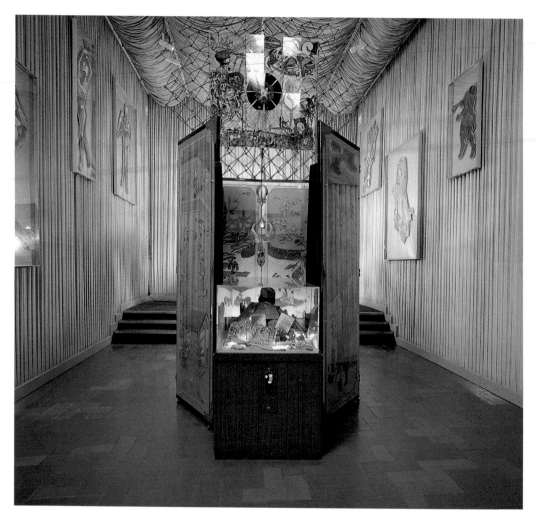

The jade princess is a cyberpunk archaeological find. Inside the body of this robotic mummy the mineral chips and printed circuits co-exist. At the end of the room where it rests, there is the replica of the inside of Bramante's Roman Shrine, decorated with sculptures of Dalinian gold.

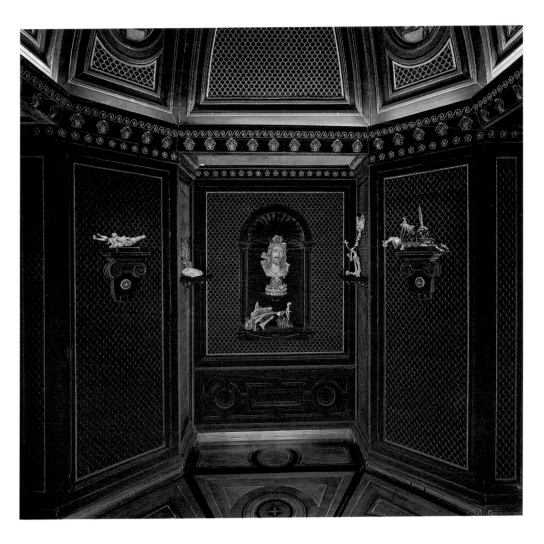

95

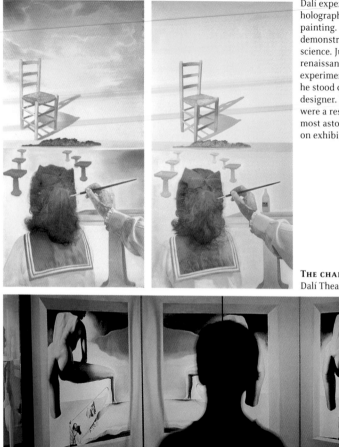

Dalí experimented with holography and three-dimensional painting. His stereoscopic works demonstrate his interest in science. Just as the masters of the renaissance had done, the artist experimented in diverse fields and he stood out as a jewellery designer. The fantastic gems that were a result of his talent, the most astonishing pieces, are today on exhibit in some special rooms.

THE CHAIR, 1975
Dalí Theatre-Museum Figueres

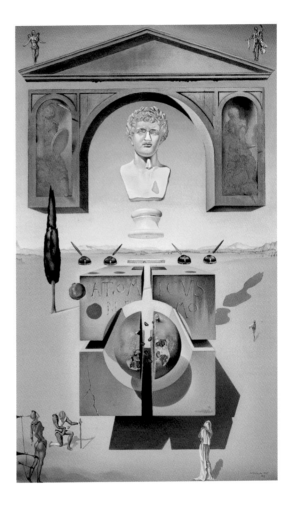

DEMATERIALISATION NEAR THE NOSE OF NERO, 1947. Dalí Theatre-Museum, Figueres

The museum also houses the work of two of Dalí's most loved companions: the Empordà painters Antoni Pitxot and Evarist Vallès. These two men, like their mentor, use their canvases to fly the flag of surrealism and modernity, always applying them to the microcosms in which they live.

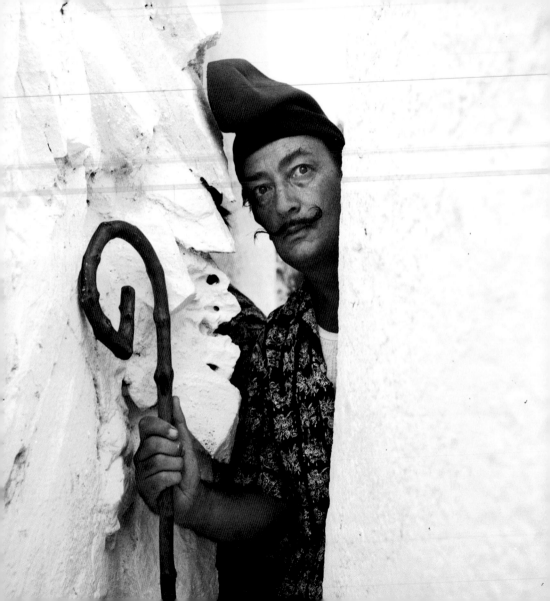

SECOND ANGLE:
PORTLLIGAT

White walls alongside the water

Dalí's tremendous passion for Cadaqués was a case of love at first sight. The diaries of his youth record the young man's desire to spend his summer holidays there. Salvador went over the calendar and counted the days remaining before setting off, just like a prisoner marking the walls in captivity.

The Dalí family had begun spending summer in Cadaqués in 1908. The notary had obtained a rehabilitated stable from the Pitxot family on the beach of Llaner, close to Es Sortell. The white house, at that time practically the only construction in the area and a few steps away from the sea, was surrounded by orchards, olive groves and imposing dry stone walls. It was perfect. The poet Carles Costa, a friend of the notary, called it, "the temple of cordiality and friendship", and added that its presence in Llaner gave off, "an aroma of flowers of the spirit of the finest fragrance".

Despite its ideal location, the house had one defect: a studio could not be fitted out there for the notary's son. His father solved the problem by renting a small space at Punta d'en Pampà, beside Port Alguer. It was a large run-down room, situated on the top part of a fisherman's cottage. From the balcony the sea and the sky could be seen, and Dalí was able to admire the boats arriving with their sun-yellowed sails open to the wind. Here he spent whole afternoons painting until it would get dark and the stars shone out.

At that time, one of his inseparable companions was Joan Xirau from Figueres, whose family also spent summer in Cadaqués. The pair of them ran uncontrollably around the streets of the peaceful village. Dalí was the instigator of "brilliant" ideas, such as spending the night in the cemetery or throwing themselves to the ground and chucking a fistful of pebbles into the air to see how many of them touched them when falling. Salvador also made friends with an unusual young man, the son of one of the cake-makers of the La Moreneta shop.

The boy was called Ángel Planells, was an avid reader of Poe and all kinds of tales of terror, and produced some drawings full of imagination. He would draw them on top of the family baker's tabletop. The Dalís' servant, who would go there to buy the bread, saw him one day scribbling away and told the notary's son. Dalí, full of curiosity, went to see him. Dalí and Planells began a relationship with shared interests that, with the passing of the years, would involve them enlisting in the international ranks of surrealism.

As a result of the hard work, the walls of the studio at Punta d'en Pampà were covered with canvases. All of them, absolutely all of them, were covered with motifs and views of the village. Dalí would very shortly produce the isolated Torre de les Creus, the area surrounding the beaches of Es Sortell and Cala Nans, as well as the luminous magnificence of Port Alguer. He also liked to climb up to the neighbouring hills and recreate, from an elevated viewpoint, the ramshackle houses of the village and the bay with the beach full of boats. Many years later, the painter confessed that the beauty of the landscape was down to its structure. "Each hill, each rocky profile, could have been drawn by Leonardo himself! Without the structure there is practically nothing. The vegetation hardly exists. Only very small olive trees, the yellowish plant of which, like old grey hair, crowns the philosophical faces of the hills, creased by holes where the flocks wither and rudimentary paths are half erased by the thistles".

The geographical discoveries of the young Dalí, however, were not restricted to the inhabited village of Cadaqués. The family had a great tendency to make boat trips. The Dalí family's boatman was Enriquet, a lazy and extravagant fisherman. Salvador was very fond of him indeed, above all from the time when, on seeing him paint a seascape, said, "Your waves are just like those of the sea, but in your painting they are much better because... you can count them!"

Positioned in the boat by Enriquet, the Dalí family usually set course for Cap de Creus, where they went into raptures over the fantastic rocky formations that shone out like old gold. Cap de Creus was a paradise of orographic cataclysms, full of crags riddled with holes and softened by the beating of the wind and salt. The young Dalí loved climbing up to the top of these rocks and pointing to the horizon with his finger. It was exciting to walk through that labyrinth of gigantic and eroded forms. The surface of the minerals conjures up outlandish forms to the human mind. The deformed stones become crooked faces, imaginary creatures or prehistoric vegetation. The inhabitants of Cadaqués, aware of the mirages, had baptised the most outstanding rocky spots with the names of the Camel, the Old Man or the Friar.

When the Dalí family disembarked in Cap de Creus, they stopped on the Tudela plain, a small green field lost among the rocky crags, and ate in the shelter of the rock known as the *Àliga*, or eagle. Not far from there, in Cala Cullaró, stands the mineral excrescence that would serve as model for Salvador in his piece *The Great Masturbator* (1929). Dalí was always a great fan of this so rough corner of the world. In the *Diary of a Genius* he would emphasise that, "The most beautiful spot of the Mediterranean is exactly between Cap de Creus and the Àliga de Tudela. The supreme beauty of the Mediterranean is similar to that of death. The paranoiac cliffs of Cullaró and Francalós are the deadest in the world. None of its forms were ever alive or current". The painter was right: walking along Cap de Creus is like is like immersing oneself into an alien, hostile and pre-human planet. Dalí transmitted his fascination with the Tudela plain to Buñuel. The Aragonese adopted it as a film set to shoot some of the most controversial scenes of the film *L'Âge d'or* (1930).

After some time, Dalí left Punta d'en Pampà to set himself up in the Llaner house, where he had a studio in a room on the second floor. By then, the white house was no longer on its own. The area had gradually been converted into a fashionable district and in 1923 the summer residences had begun to proliferate. Cadaqués began to be a tourist resort with possibilities. This then, was the village that the poet Federico García Lorca discovered at Easter 1925, on being invited by the Dalí family. With Salvador and Anna Maria as guides, Lorca drank garnacha wine and ate *crespells*, sweet, sugary fritters, and met the fishermen and the famous Lídia; he was so fascinated by her senseless reasoning that he took a portrait of her back to Granada. During those brief vacations the writer was enchanted by the vision of the "Latino sea" and its "magnificent desert of vineyards and olive groves".

García Lorca would repeat his visit to Cadaqués in the summer of 1927. He greatly loved travelling by boat to Tudela; there they ate rabbit and slept the siesta sheltered by an enormous hollow rock. One morning, while Salvador was shut away in his studio, Federico and Anna Maria went to the beach of Es Sortell and collected stones, fossils and pieces of polished glass that they took to the artist so he could include them in his paintings. Every Sunday, Federico and Anna Maria went to mass. The mixture of the canticles and organ music, added to the baroque-style of the church's main altarpiece, almost made the poet levitate. On leaving, they went towards the Mallorquina bakery to buy some pastry fish. The fact is that Federico's presence brought unrepeatable charm and happiness to those holidays. When he had to leave them, called for by his father, the entire Dalí family felt his departure as a true loss.

The summer of 1929, in contrast, was completely different. It was a summer of revolution and disorder: at the beginning of August, Gala broke into the Dalinian microcosm, never to leave it. Helena Ivanovna Diakonova, her husband Paul Eluard and their daughter Cecile arrived in Cadaqués and stayed in a room in the Hotel Miramar. The appearance of

Gala was like a flash of lightning. When Dalí saw her dressed in a swimsuit on the beach of Llaner, he was spellbound. He fell in love instantly and totally. Despite the fact that initially Gala rejected the painter, due to the extravagant manner in which he tried to attract her attention, they very soon became intimate friends. Luis Buñuel was an involuntary witness to the couple falling in love. The Aragonese was staying at the home of the Dalí family with the intention of working with Salvador on the script of the film *L'Âge d'or*, but due to the artist's confusion, the work plans were put to one side.

Paul Eluard did not take long in leaving Cadaqués and returning to Paris. Cecile and Gala stayed on. The growing attraction between the painter and the married Russian woman caused a split amongst the Dalí family, since the notary and Anna Maria were totally opposed to the relationship. In that turbulent month of August, the journalist Josep Maria Planes visited Cadaqués and was in the Llaner house without realising what was going on. What he did record was the hyperactivity of the young artist: "He gets up very early in the morning, at unearthly hours by our standards; and he gets down to work like a man possessed. He just takes a few moments to swim and sunbathe beneath the blazing sun".

Gala and Cecile left Cadaqués at the end of September. Dalí met up again with his muse in Paris where, on the 20th of November of the same year, he opened an exhibition in the Goemans gallery. Among the paintings was a piece entitled *The Sacred Heart* (1929) which contains the following sentence, "Sometimes I spit on the portrait of my mother for PLEASURE". When the notary and Anna Maria found out about these words, they flew into a rage. The notary expelled Salvador from Figueres, but allowed him to go to Cadaqués to reflect, where along with Buñuel, he continued writing the film script. After a few days, Dalí received a letter from his father stating that he was irrevocably exiled from the family home. As a reply, the painter cut his hair and buried it on the beach of Llaner. Then he shaved himself bald and made a self-portrait with a sea urchin on his head. The peaceful summers in the white house had ended. Portlligat was at the point of entering onto the stage.

A house with a surrealist soul

BETWEEN CONFUSION AND AMAZEMENT

The Salvador Dalí Museum-House in Portlligat is an unrepeatable gem: a fabulous example of a surrealist home. Visiting it enables us to imagine what could have occurred in the fields of architecture, interior design, decoration and design if this aesthetic revolution had triumphed and would have been able to be applied unwaveringly to daily life.

As occurred in other Dalinian projects, the artists identification with his home and environs was absolute: "I am not at home except in this place", he asserted, "In any other place, I am just passing through". Far from this habitat, the painter felt as unprotected as a turtle without its shell. For a normal person, however, living in that complex labyrinth would have been unbearable. The superimposition of irregular elements and their compulsive variety, added to the narrowness of the corridors and smallness of some of the rooms, could have caused anxiety amongst even the most impassive souls. The decoration seems to be based on the saying "A little bit of everything". The most extreme surrealism, the most restrained classicism and the most aberrant kitsch all have a presence in the space and obey the following saying: "Bad taste is the most creative thing there is. Good taste, everything that is French, is sterile". Dalí *dixit*.

To understand the general tone of the house, you just need to take a glance at the first room, the Bear Hall. A stuffed bear that guards it, a gift from Edward James to the couple, explains the name of the room. The beast, corpulent and moth-eaten holds a lamp built with a perch. However, if the lighting function should be considered as insufficient, the animal also doubles up as an umbrella stand, letter holder and harquebusier. The wild animal is a good metaphor for the jealousy with which the Dalí family conserved their privacy: they were excellent hosts, but never allowed anyone to stay overnight in their refuge. Behind the bear, a stiff and erect owl sticks out its head. Both animals bear witness to the artist's liking for taxidermy, a passion we see represented in other rooms. "Here, in this house, everything is preserved," explained the painter sarcastically, referring to the reiterative decoration of houseleeks, one of Gala's favourite flowers.

Before such a profusion of decorative contrasts, of objects that confuse us as much as they amaze us, an inevitable question arises. What criteria did Gala and Dalí follow when piling up such a wide range of items? We will never know the true answer. We can only guess that such excess responds to a personal, private and obsessive mythology. We can come across proof of this in the dining room: at first sight we discover candelabras, esparto rugs and marine ornaments; but what really attracts the attention are the linseed chairs, of different sizes, close to the fireside. Above each one of them rests a *gorra de cop* (straw hat with a semicircular section, projecting out to avoid receiving bangs on the head) in sizes proportional to the chairs. Does this composition have any hidden meaning? Perhaps we can find the answer in *Diary of a Genius*. Dalí recounts in the book that, on the 6th of September 1956, he bought ten caps in Figueres because he had banged his head. The painter adds, "On returning, I placed the hats on the chairs of different heights that Gala had decided to buy. The almost liturgical image of such a setting gave me the beginnings of an erection. I went to my studio to pray and give thanks to God. What I had just done was the most harmonious unholy alliance of all possible unholy alliances". This association shows that behind each element of the home lays a strange and crazy logic.

It is worth remembering that these extravagant unholy alliances are, more than often, the result of the fusion between high culture and popular culture, a doctrine that Dalí always proclaimed. The artist's intellectual interests, vast and heterodox, were perfectly reflected in the large library in his house. The

economic position of his family, along with the fact that his uncle Anselm Doménech ran a bookshop in Barcelona, supplied him with his love of books. The wealth of volumes in the house in Portlligat surprised the writer Josep Pla: "The first time I saw them I was astonished because I had practically never seen a book inside a painter's home or studio". Once again, Dalí was the exception to the rule.

WORK AND FREE TIME

Salvador Dalí took his work extremely seriously indeed. For this reason it should be of no surprise that the studio is one of the most important rooms in the building. It was the place where the painter concentrated, lost himself in thought away from the world and undertook marathon work sessions. Despite having worked in other parts of the house, from 1950 onwards he was able to use this studio definitively. The room, peaceful and well lit, still preserves the unspoken witnesses of easels, brushes and solvents.

The room has two windows, the front one facing the Bay of Portlligat, closed by the elegant silhouette of Sa Farnera, and the north-facing side window. In this space, supplied with the essential tools, Dalí spent many hours of his life. He was a compulsive worker. He began work at dawn and did not put down his palette until the light vanished behind the Pení. He only allowed himself breaks to swim, eat and have an afternoon nap. In order to distract himself from the more mundane aspects of work, Gala would read out aloud to him.

Next to the studio, in the Model's Room, there are more tools, optical apparatus and an amalgam of very diverse objects. Amongst them we can discover a small plaster bust that represents the emperor Nero. This piece was used as the model for *Dematerialization Near the Nose of Nero* (1947), produced when Dalí was fascinated by nuclear fusion. It is worth comparing the small size of the bust with the magnificence of the pictorial result. The artist, when he set his mind to it, knew how to get the very most out of even a breadcrumb.

Besides the studio, most of the rooms in the house are fitted out for the specific chores of daily life. The only room that is an exception to this is the Oval Room, which makes up Gala's private space. It is her intimate space, for pleasure and leisure, where she reads and receives distinguished visits. The room, built in 1961, is hemispherical and has haunting and reverberant acoustics. The structure is inspired by a Dalinian design for a North American ballroom, which had to have the shape of a sea urchin. Gala fell in love with the project and asked for a home-sized version of it. The artist finished it with an upholstered bench that borders the wall, and a fireplace flanked by elephant tusks.

The Oval Room is one of the few rooms in the house that has a door, although it is camouflaged by a soffit. To get to Gala's secret *sancta sanctorum* you have to pass an austere dressing room and the photography room, which has the cupboards papered over with magazine photos and cuttings, in which the couple appeared in the company of all kinds of figures. For the painter, hanging all these images on the walls, instead of closing them off inside albums, was a way of having the people present.

All the photos clearly capture the public life of Dalí and Gala. If we take into account the emphasis that both of them gave to social relations, it is logical that the outside spaces of the house would be given over to daily life and the glorification of free time. One of the most charming corners of the estate boasts of the name Milky Way. It is reached by means of the terrace and its name comes from the whitened flagstones that lead to a small cove, the beach of En Sisó, where the couple would often swim. The way is bordered by pomegranate trees, which produce one of the painter's

favourite fruits. Who knows if this passion was stimulated, as far back as 1913, by his father buying a still life, the work of Ramón Pitxot, the exact title of which was *Granadas*, pomegranates?

Above the terrace we come across the courtyard. It is reached through a labyrinth built into the rock that hides a small summer dining room. Going along the corridor we come out in the courtyard where Dalí and Gala invited their guests to pink champagne or held al fresco suppers. Among the ornamental elements feature two enormous window boxes, in the form of a cup. There is also a reproduction of the *Illissus* of Phidias, created for the Parthenon of the Acropolis in Athens. Dalí featured this sculptural piece in the painting *Rhinocerotic Disintegration of Illissus of Phidias* (1954), where the athletic torso disintegrates over the Bay of Cadaqués, facing the popular islet of Es Cucurucuc.

The rear part of the courtyard comprises the swimming pool area, built in the winter of 1967. The swimming pool is famous for its brazenly phallic shape due to the set of fountains surrounding it and the small shrine that crowns it, based on the outer packaging of a radio. The *pastiche* of the scenography defies any logical classification: two lion fountains share the space with a labial sofa, posters of Pirelli tyres and reproductions of Bibendum, the Michelin mascot.

If instead of going towards the swimming pool, we continue through the labyrinth, we will reach the olive grove that marks the property's boundaries. Here is a curious sculptural arrangement, the *Christ of the Rubbish*, made from the remains of a flood. Undoubtedly, however, the most stunning piece to be seen is the Dovecote of the Pitchforks, crowned by an enormous egg. Dalí loved watching the birds at dusk, when they flew over the rooftops. "At the big events or in grand official openings", he said, "flocks of doves are released; we have them every day". He was attracted to them because they were a symbol of peace and due to the fact that a dove with an olive branch in its beak would have announced the end of the flood. Dalí stated in a serious tone, "We, here, have the two elements: doves and olive trees; this is why we can be at peace, because in Portlligat peace is ensured". Peace and security. This is what the painter had come to look for here. He achieved both things thanks to the presence of Gala and the white walls that gave him shelter.

A REFUGE IN PORTLLIGAT

Despite having broken the links with his family, Dalí did not want to give up his spiritual and telluric links that united him with Cadaqués. Having taken refuge in Paris with Gala, he recalled the hut in the Bay of Portlligat where he would keep his painting tools. Portlligat is an area where the sea is very shallow, closed off by the islet of Sa Farinera to the east. At that time it was an uncultivated land, used as an operational base by a small group of fishermen who would spread their nets in front of the small beach.

The owner of the hut that Dalí was interested in was called Lídia. She was an enlightened fisherwoman who, according to the painter, "possessed the most magnificent paranoiac brain, apart from mine, that I have ever known". This unique woman's sons used the hut, which had a tumbledown roof, to leave their fishing gear. The artist got in touch with Lídia, who agreed to sell him the space and to make the minimum repairs required, so that this den, some 22 square metres, could be habitable when the couple returned from Paris.

Salvador and Gala went to Cadaqués in March 1930, to the chagrin of the notary, who did all he could to stand in their way. For the couple, who travelled loaded up with suitcases and tools, it was no easy task reaching the spot. It was impossible by car: after having passed the hermitage of Sant Baldiri and the

cemetery walls, there was only a rocky and impassable goat track. The couple transported part of their baggage on a fisherman's boat; the rest arrived later, loaded on a mule.

The artist and his partner stated that the hut had minimum living conditions, but if they wanted drinking water they had to pump it from a nearby well. Neither was there electric light and they had to use petrol lamps. The only room in the hut was used as the lounge, bedroom, kitchen and studio. The Dalís settled into their new home. They only went to Cadaqués, by boat, to stock up on the things they needed. Their visits to the village, therefore, were sporadic: they spent whole weeks without setting foot in it and fed themselves on the soles, sardines and lobsters that the fishermen sold them. The fishermen were the Dalí couple's only company in these hard times. The bay was deserted and silent at night. The timid blinking of the petrol lamp, sometimes alight until the early hours, was the only perceivable sign of human life.

The purchase of Lídia's hut was made official on the 20th of August, thanks to some financial help from the Viscount of Noailles, and on the 22nd of September the painter bought another that was located very close by. At an interview he gave in Paris at the end of this same year, the son of Figueres recalled the importance of this refuge: "Within fifteen days I return to Portlligat, where I have built a tiny house with nickel, glass and oilcloth. There I intend to spend a long period of time working".

That is just how it was. Portlligat became his spiritual shelter, in the hidden residence where he cut himself off to work undisturbed. From that time on, the quiet and calm sea, the rounded crests of Sa Farnera, the small fishermen's harbour and the tower of an old mill, perched over the hill that closes the bay, became ever-present actors on the Dalinian stage. The artist loved saying, "In Portlligat I take care of my orchard and my boat: in other words, of the canvas I am fin-

ishing; like a good worker, I covet simple things: eating grilled sardines and strolling with Gala along the beach at sunset and seeing how the Gothic rocks are transformed into nightmares by the darkness".

In 1932, the Dalís fitted out the second cottage and from then on, over forty years, the house was gradually extended and would be transformed according to the owners' requirements. As time went by, the couple bought up the neighbouring cottages in order to annexe them to their building. They interconnected the different dwellings and turned them into a confusing and complicated labyrinthine microcosm. The Barracks or clock hut, thus named because of its sundial, was also a notable purchase. The painter bought it in order to keep it in its original state, just as it is shown in some canvases, for example *Noon (Barracks at Port Lligat)* (1954). The hut, with the dry stone wall facade intact, currently houses the cloakroom of the House-Museum.

After many decades of works and remodelling, Dalí ended up with an unusual and surprising construction, which despite everything, fits perfectly into the environment. It seems to be genuine and authentic, of the land itself. It would seem false and erroneous on any other part of the coastline.

The first time anyone visits this white, resplendent complex it is impossible not to be dumbfounded. While the car leaves the hermitage of Sant Baldiri behind, standing out from the cypresses and olive trees, like archaeological phantasmagoria, is a dovecote spiked with pitchforks, a pair of colossal heads and some giant-sized eggs. The visitor receives the information in short bursts, while getting the sensation of approaching a spot where some enigmatic mystery will be revealed to them. This sensation becomes more noticeable on approaching the water and discovering that, just in front of the artist's home, an energetic cypress emerges from a shattered boat. This pagan totem pole, where the sea and the land

blend in together, is the embodiment of the oil painting *Apparition of My Cousin Carolinetta on the Beach at Roses* (1934). Its purpose is to warn us that we are about to enter into a Wonderland. We must sharpen up our senses.

If we are overwhelmed by the spot, above all if the weather favours us and a cloud floats over the bay, we can rest by the white fountain and let the fresh air, the harshness of the salt residue and the tickling of the calm invade our senses. As if we did not know, this fountain has a history: it appears in works as important as *Portrait of Gala with Two Lamb Chops Balanced on Her Shoulder* (1933), and was used as a meeting point for hallucinating hippies in the seventies, who saw Dalí as a soul mate and a type of guru.

Taking in the view of the closed sea may produce a feeling of melancholy within us. It is no coincidence that the painter would decide to boost this effect and plant cypresses in order to attain a romantic air that reminds one of the artwork by Arnold Böcklin, *The Isle of the Dead* (1880). To underline the appearance of the artificial and enigmatic lake of the bay, the couple kept different swans that swam among the waves. The happy conjunction of the swan, the nude body of Gala and the placid water resulted in the magnificent painting *Leda Atomica* (1949). Obsessed with extending the mysterious atmosphere of the spot, at the end of the fifties Dalí announced his desire to let loose a pair of rhinoceroses on the beach, much to the consternation of the local inhabitants of Cadaqués.

In any case, Portlligat provided a portion of unmistakeable mysticism to the painter's work. If in his early days, arising from him were geological hallucinations, liquefied bodies and deformed objects, coming from the mire and the abysses of the subconscious, with the passing of time, all these disturbing traits would be set to one side and replaced by icons of Christian imagery. Then the artist converted the by no means virginal Gala into a kind of guardian deity of the bay, like an angel or Madonna. Portlligat would become a Garden of Eden, where angels and fishermen lived harmoniously by the harbour, or a crucified Christ, *Christ of St. John of the Cross* (1951), flew above Gala's yellow boat.

Clearly, the spirituality and harmony of the spot were tied to the loneliness that Dalí felt there. He would often say: "Portlligat is a kind of prison cell that enables me to be alone with myself". The spread of tourism, however, ended this invulnerability. Swarms of people of all nationalities came to the spot, attracted by the maestro's *glamour*. The advent of the tourists ended the heavenly peace of the refuge. At the beginning of the seventies, Dalí explained his brilliant formula for escaping from the recently arrived hordes. The tourists follow me even when it's time for a swim. But I have discovered the way to be able to bathe alone. The foreigners do not like the algae, and I have found a solitary cove full of algae. To start with it bothered me a little. Now I love feeling how the algae caress my legs and skin. From now on I won't be able to have a bath at home unless some noodles are thrown into the bathtub". The recipe seems infallible.

The golden age of seafaring in Cadaqués has left a visible mark on its bay. Boats always dropped anchor convinced they would be well received. Inland, the blinding whiteness of the houses and the stone mosaics make up a clean and simple urban layout, of pleasurable effects.

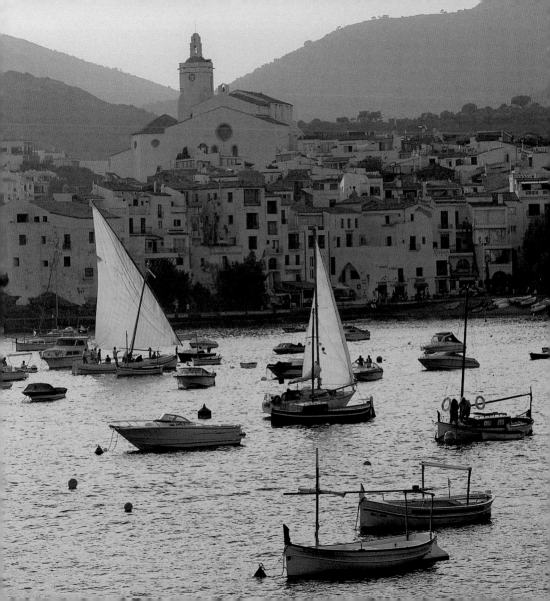

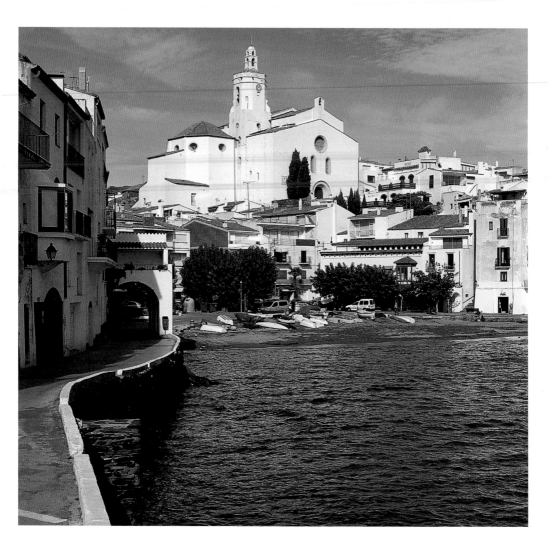

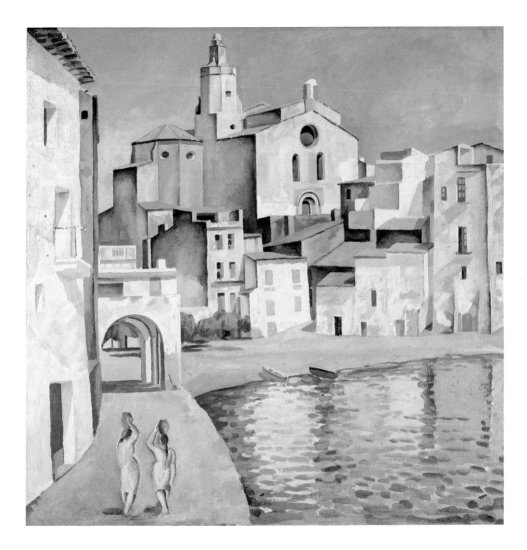

PORT ALGUER, 1923-24. Dalí Theatre-Museum, Figueres

The town's idiosyncratic ways have gradually matured with the passing of time. For several decades now, young women no longer stroll around with the earthenware jugs on their heads and the divers have disappeared. Tourism has changed many customs, but the Casino maintains its function as a friends' meeting point.

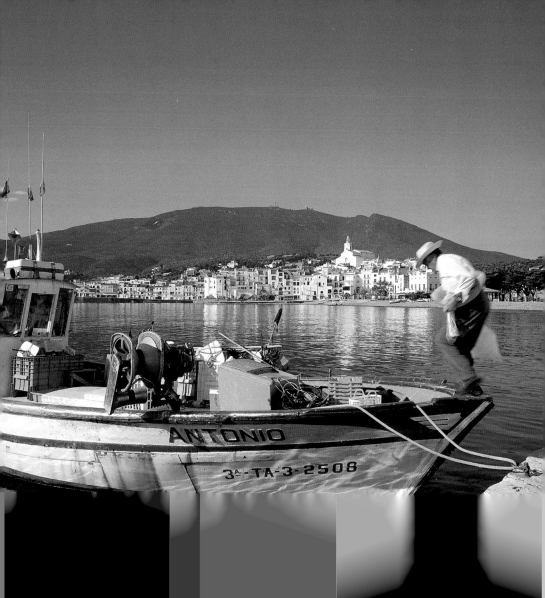

Es Cucurucuc, like a rhino horn emerging from the sea, is one of the most remarkable islets in the Bay of Cadaqués. Dalí turned it into a forceful symbol of the Mediterranean, of the landscape he dreamt about when he lived outside Catalonia.

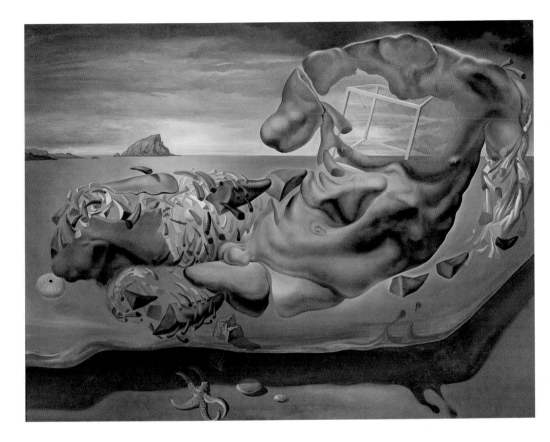

Rʜɪɴᴏᴄᴇʀᴏᴛɪᴄ Dɪsɪɴᴛᴇɢʀᴀᴛɪᴏɴ ᴏꜰ Iʟʟɪsᴜs ᴏꜰ Pʜɪᴅɪᴀs, 1954. Dalí Theatre-Museum, Figueres

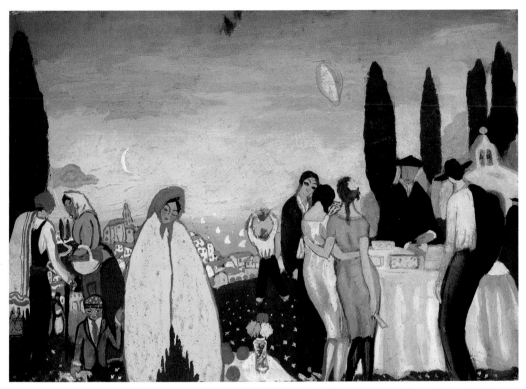

FESTIVAL AT SAN SEBASTIAN, 1921. Teatre-Museu Dalí, Figueres

The artist was fascinated by the annual festivals that were held in the hermitage of Sant Sebastià. Dalí recorded in the diaries of his youth the impression that the dancing and singing had on him of the *patacades*, compositions of a satirical nature, dedicated to well-known figures of the town.

The coves and small beaches of Cadaqués, full of pebbles battered by the weather, were the daily stage of the painter's dreams. Their blue, clear water was turned into the perfect mirror to reflect spectres, obsessions and hallucinatory delusions.

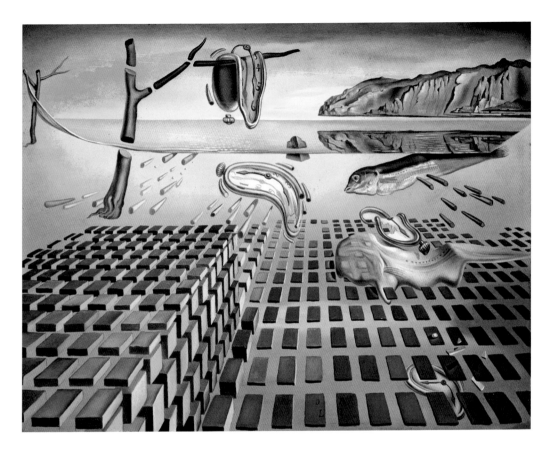

THE DISINTEGRATION OF PERSISTENCE OF MEMORY, 1952-54
Salvador Dalí Museum, St. Petersburg, Florida (USA)

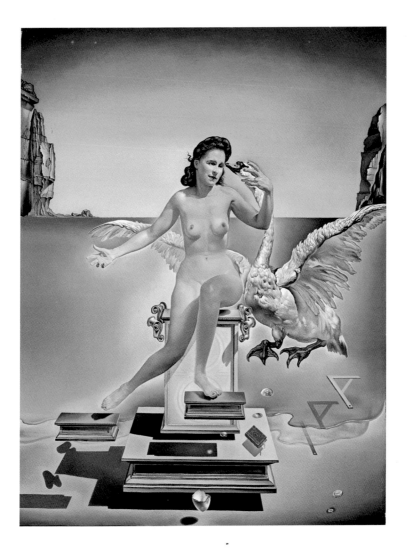

LEDA ATOMICA, 1949. Dalí Theatre-Museum, Figueres

Sea urchins were the reward with which Salvador Dalí's father congratulated his son for his first artistic success. From that time on, these marine creatures were present in the painter's life and work, serving him as models for paintings, architectural designs and aesthetic theories. Fishing for sea urchins is a deeply rooted tradition in Cadaqués.

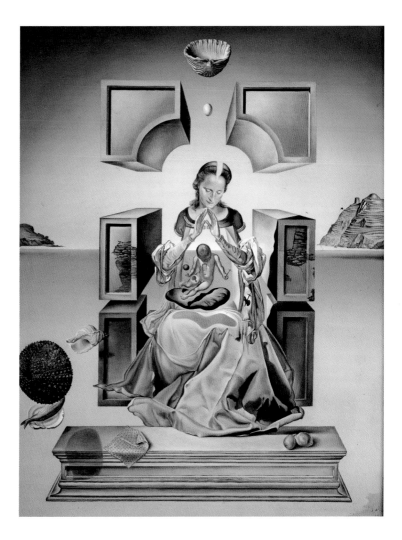

THE MADONNA OF PORTLLIGAT, 1949
Haggerty Museum of Art, Marquette University, Milwaukee, Wisconsin (EUA)

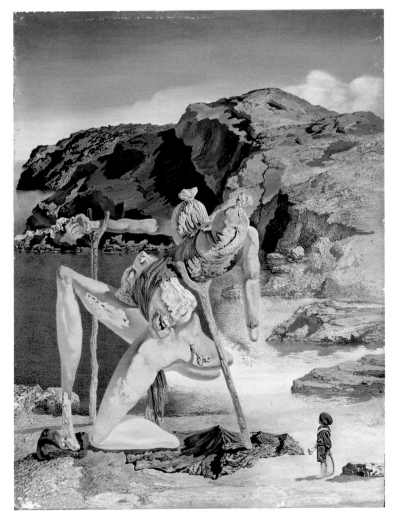

"IT WOULD BE DIFFICULT TO FIND SUCH A DELIGHTFUL COASTLINE ANYWHERE ELSE IN THE WORLD, WITH THIS MINERAL AND GEOLOGICAL GRANDEUR"

THE SPECTRE OF SEX APPEAL, 1932. Dalí Theatre-Museum. Figueres

The rocky spots of Cap de Creus, cut by the sea salt and tramontana wind, give rise to surprising shapes in the eyes of visitors, shapes from which Dalí extracted the raw material of many paintings. The artist identified with the spot so much that he stated that he was the embodiment of this landscape.

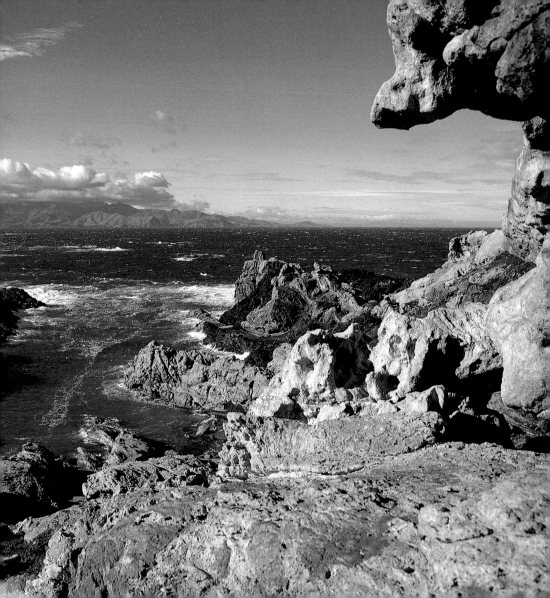

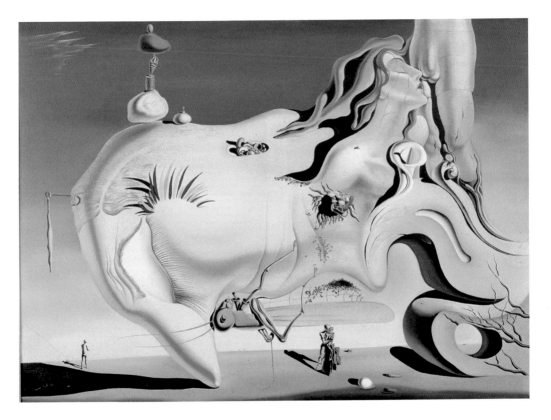

THE GREAT MASTURBATOR, 1930. National Museum Art Centre Reina Sofía, Madrid

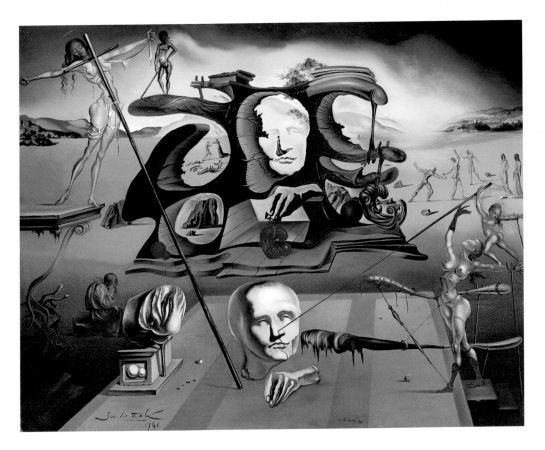

NAPOLEON'S NOSE, TRANSFORMED INTO A PREGNANT WOMAN
MELANCHOLICALLY WALKING HER SHADOW AMIDST ORIGINAL RUINS, 1945
Fundació Gala-Salvador Dalí, Figueres

The chapel of Sant Baldiri, sheltered by the cypresses, opens the way towards the beautiful cemetery of Cadaqués. A girl-bell swings in its small bell tower, an ever-present icon in the artist's cosmogony. The piece was a gift from Dalí himself, who saw the hermitage as the gateway to Portlligat.

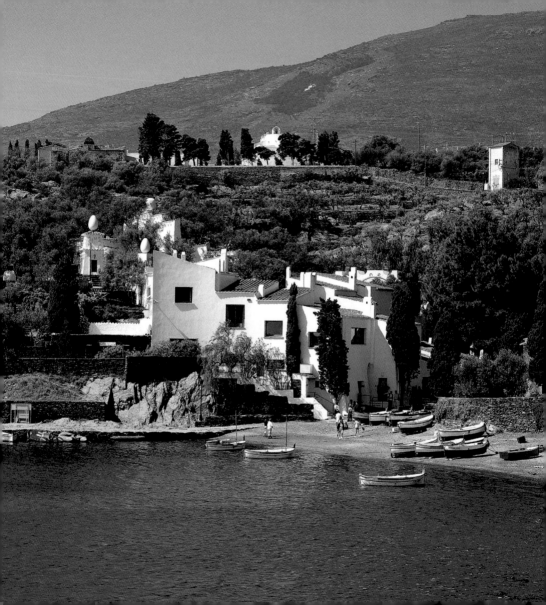

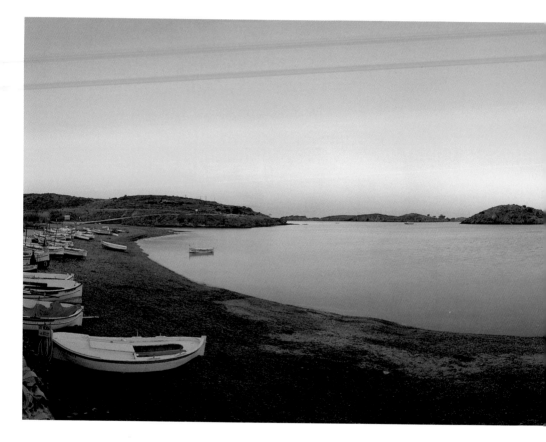

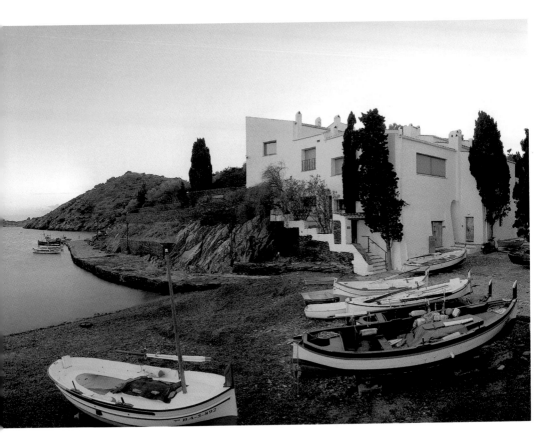

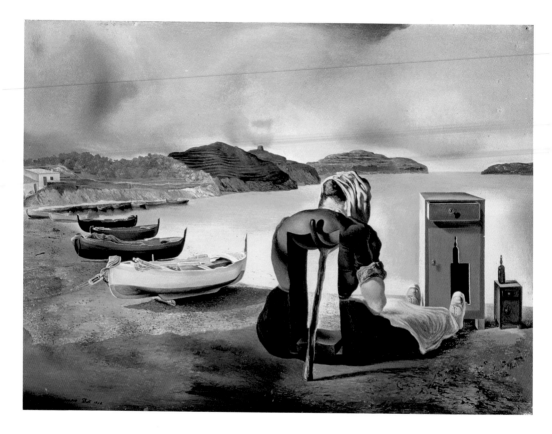

THE WEANING OF FURNITURE-NUTRITION, 1934
Salvador Dalí Museum, St. Petersburg, Florida (USA)

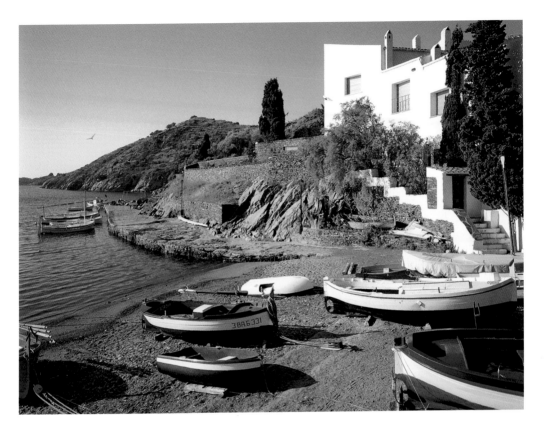

The boat and the cypress tree reveal the fascination the artist felt for the landscape of the sea and the land. This emblem featured in his paintings, as an enigmatic icon, leaping around amid sandy beaches, with phantasmagoric figures and disorientated characters moving around.

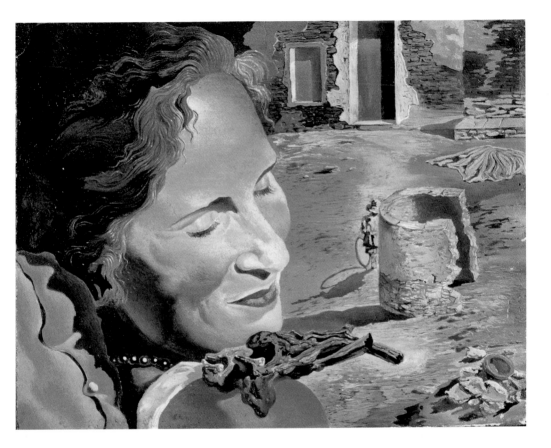

PORTRAIT OF GALA WITH TWO LAMB CHOPS BALANCED ON HER SHOULDER, 1933
Dalí Theatre-Museum, Figueres

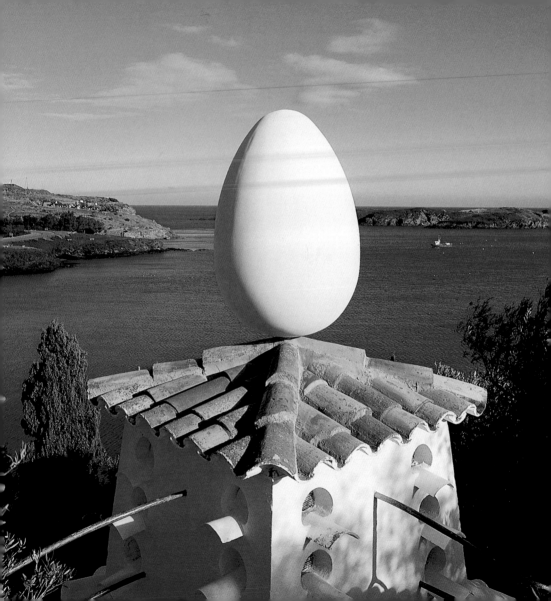

The rocky mounds that close off the bay of Portlligat provide it with the feeling of a quiet, serene and isolated spot: a corner of the world where space and time crystallise placidly. The silvery hairs of the olive trees give it the patina of the ancient mythological places, associated with the Olympian gods. When the weather was fine, Gala and Dalí swam in these coves.

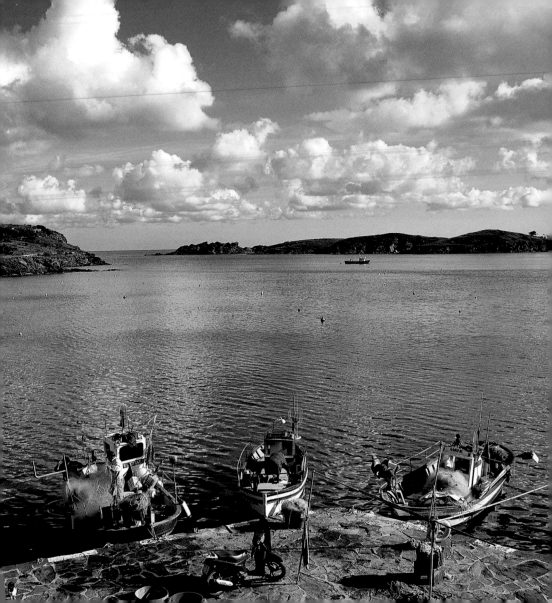

The house in Portlligat shows that the painter's crazy aesthetics were applicable to popular Catalan architecture, industrial design and interior design. The results, nevertheless, are diverse in character and often incomprehensible. Dalí and Gala's private mythology is combined with a very personal taste which is strident and rather obsessive.

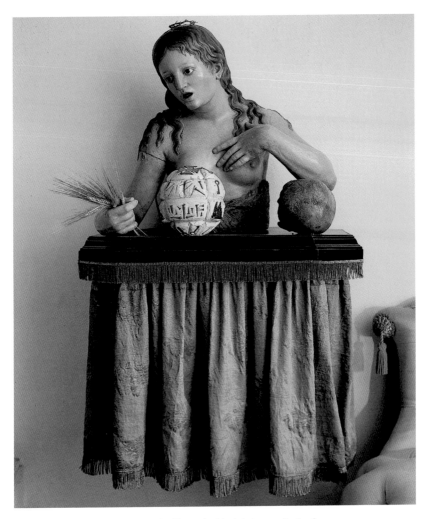

The swans in the library had had their age of splendour
in the waters of the bay. The painter wanted to preserve them stuffed.
Taxidermy gave him the idea of continuity, of permanence.

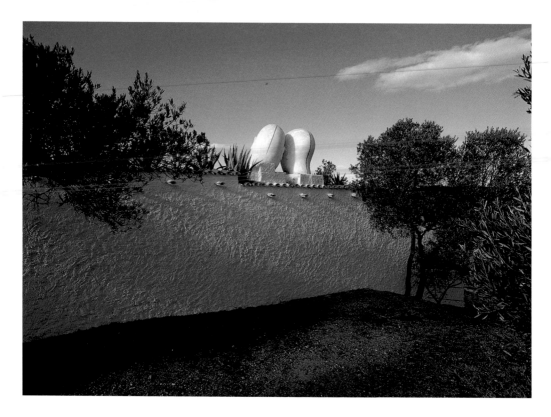

Dalí explained that he and Gala were the children of Jupiter and Leda. They had been hatched from some eggs like those that decorated his garden. The moment that they broke the shell that protected them, they became immortal brother and sister.

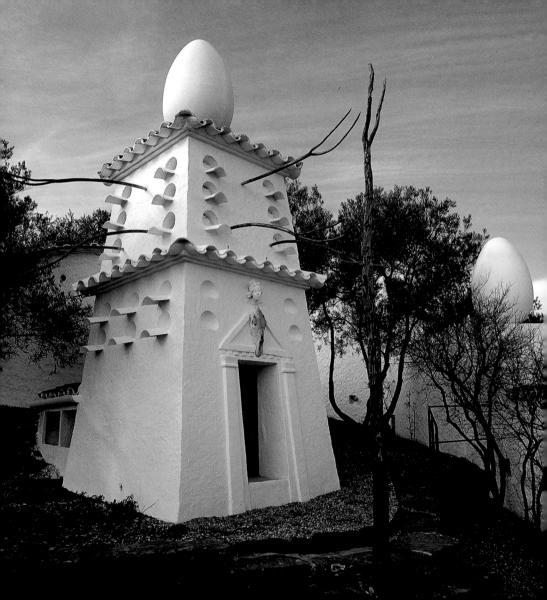

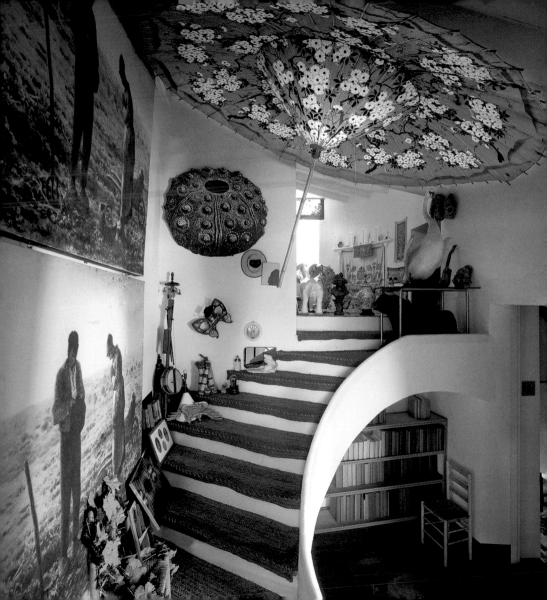

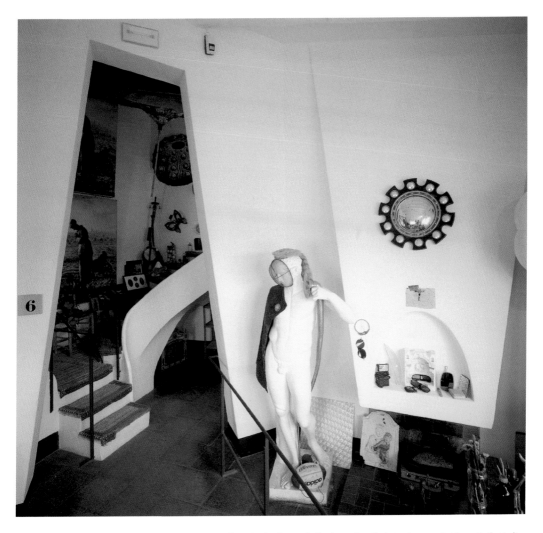

A door, in the form of a broken triangle, introduces us to the artist's studio.
The objects inside the studio recall the laboratory of a modern alchemist.

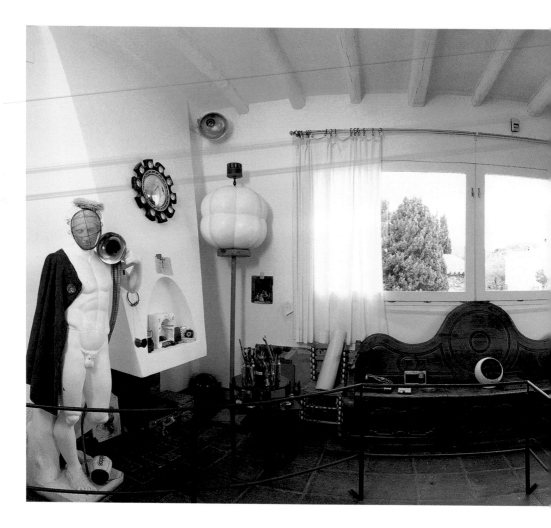

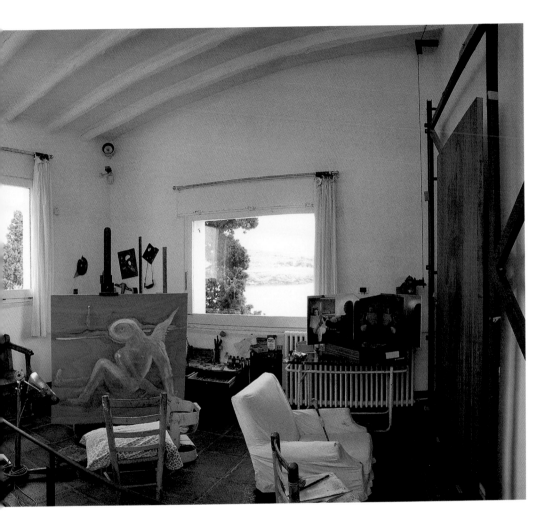

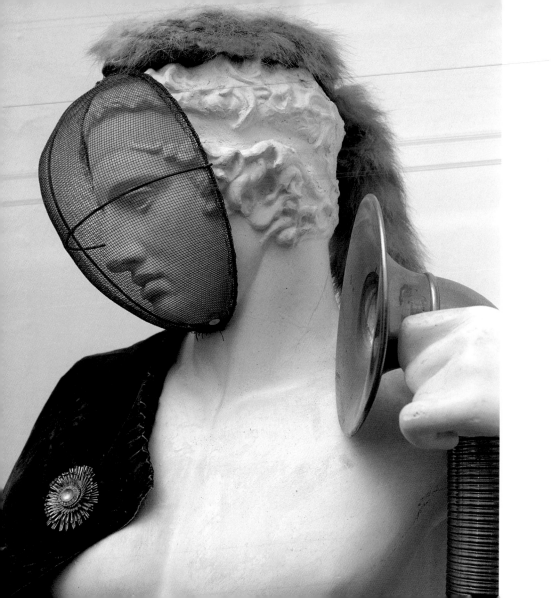

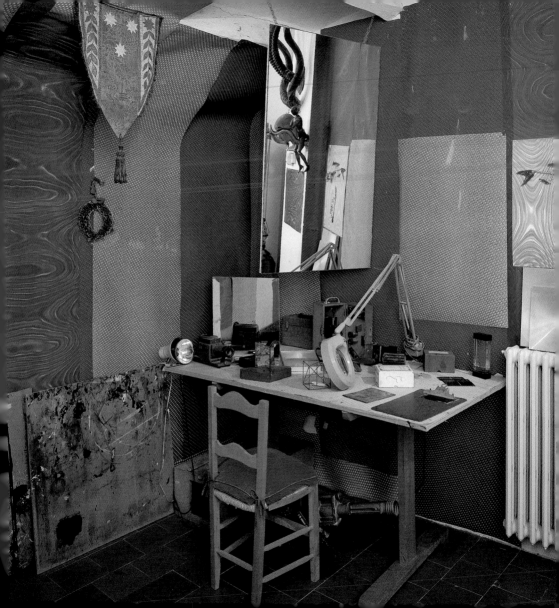

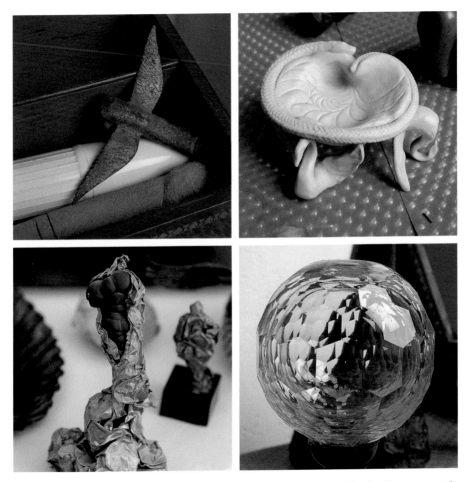

Optical instruments were tools that were widely used by the artist, always in the search to be able to represent the world in which he lived with a similar quality to that of a three-dimensional diorama. Dalí represents the blending together of the ideal of Renaissance man with that of the 20th century avant-garde artist.

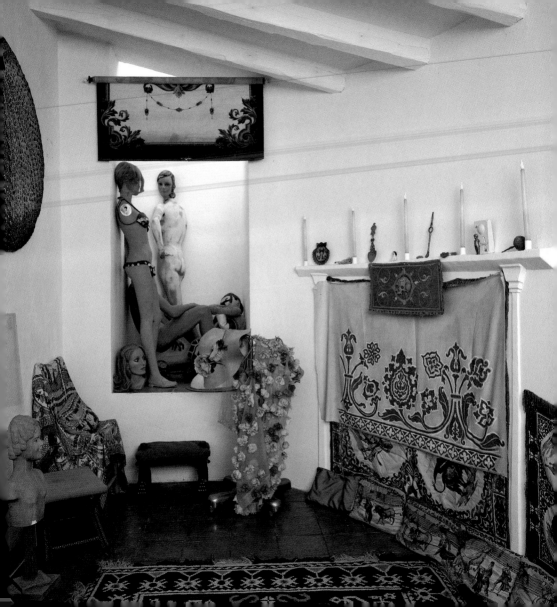

Mannequins were a recurring theme in the work of Dalí. In the 30s, he used them to represent the "surrealist woman", a mannequin with a head of red roses, and the "spectral woman", a mannequin disassembled in pieces.

The couple's bedroom is in an elevated position in order to appreciate the landscape more. Seven steps lead to the bird room, where the cages occupy the same space as an upholstered bench with the portrait of Pope John XXIII. The superimposing of spaces is the result of the way in which Dalí made full use of several fishermen's huts to build his home.

"NONE OF THE PALACES OF LOUIS II OF BAVARIA
AROUSED IN HIS HEART THE YEARNING THAT THIS
LITTLE COTTAGE INFLAMED IN GALA'S HEART AND IN MINE"

The austere bathroom leads to the photography room. Here, stuck to the cupboard doors, are photos and press cuttings that display the couple's social success. The painter preferred to have the pictures on view instead of having them closed in albums.

The courtyards of the Dalinian mansion, where the lavish olive trees reign, are an amusing jumble of Mediterranean classicism and labyrinthine corridors. Here the couple held lively parties and suppers, swayed by the aromas of rosemary and lavender.

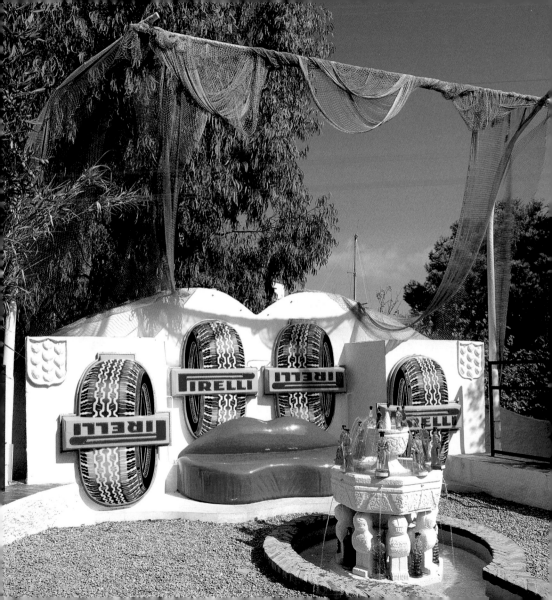

The purest pop art and the most useless kitsch live shamelessly side-by-side
in the gardens at Portlligat. Dalí had no problems in twinning high culture with
the most popular and banal icons. This fact, along with his special talent for
self-publicity, turned him into a post-modern author *avant la lettre*.

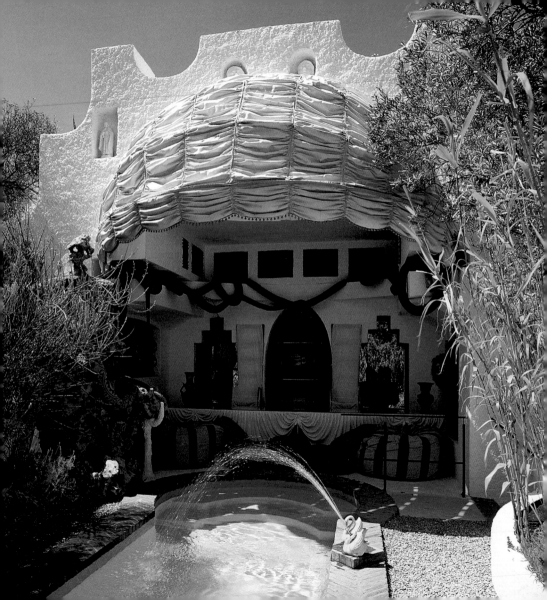

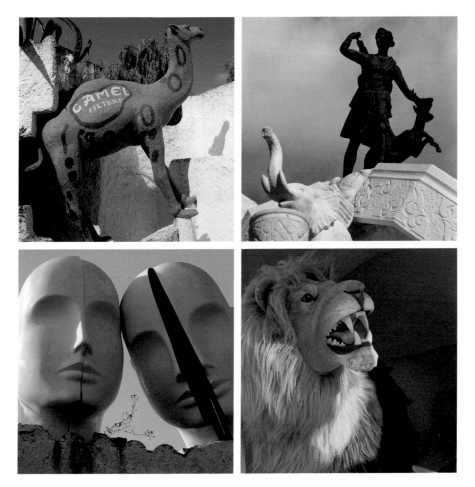

The swimming pool and its environs are a subjective and contemporary version of the famous gardens of the Alhambra in Granada. The phallic shape of the swimming pool, crowned by a shrine, would raise a smile on the faces of the more watchful guests.

THIRD ANGLE:
PÚBOL

A castle for Gala

The creative universe of Salvador Dalí, the most direct source of his inspiration, is concentrated in Alt Empordà. Despite this, as we have pointed out previously, the painter always maintained links with the geography and people of the neighbouring county. This area, also known as the Empordanet, is bordered by the Gavarres range, to the southeast, and by the Montgrí massif, to the north. Close to the coast of the Montgrí emerge the Medes: seven rocky islets, rich in underwater fauna. Dalí would proclaim himself "Lord" of these islets, with an air of nostalgia, before the New York journalists.

The Baix Empordà, as a whole, is a more rounded and gentler land than its big brother. Perhaps the sky there is more boxed in and, with the exception of the plains bordering the River Ter, we come across a land full of rolling hills and small promontories, dotted with holm oaks and pines. To take in this tapestry woven with yellow, brown and green threads, which advances as far as the Mediterranean, it is well worth climbing up to the sanctuary of the Ángels. In this hermitage, Dalí and Gala were married on the 8th of August 1958, in a private and totally secret ceremony. It seems quite contradictory that a confirmed publicity seeker, as the painter was, would hide himself from the spotlights of the press in this way. Until this day nobody has ever seen a graphic image of this wedding, but we know that the couple posed for the photographer Meli the next day and hung the souvenir picture in Portlligat.

This unusual discretion, this fleeing from the flashbulbs and the cameras, prefigure what Gala would seek out in the Empordanet ten years later. By then, the muse was 74 years old and would no longer have the enthusiasm to partake in public relations. She no longer feels as comfortable as before, in Portlligat. She wants solitariness and peace. She needs her own retreat, where she can disconnect from the environment of the genius and be able to be alone with her companions. When Dalí becomes aware of his wife's desires, he decides to please her and tells a friend, the constructor Emili Puignau, that he wants to buy her a castle.

The painter has, for a long time, had the fantasy inside his head of owning a castle: in the thirties he had promised Gala that he would buy her a palace in Tuscany. In 1948, Dalí has the idea again: he hands out photos to the Madrid press. They are snaps taken in the Park of the Monsters, in Bomarzo, on the outskirts of Rome, which are used to announce the purchase of a small palace nearby. He states that he will alternate his stays in Bomarzo with Portlligat, but like so many of the artist's statements, the prophecy does not come true.

Two decades later, the obsession for a fortress is reborn in the surrealist's mind. However, seeing as Gala is now an elderly woman, the location of the fortress needs to be within easy reach and not very far from the Empordà. Keenly aware of these conditions, Puignau will unsuccessfully look into the possibility of the Tarragona castle of Miravet. Despite there being no documental record in evidence, it seems that the artist's collaborators sounded out, also unsuccessfully, the castle of Quermançó, located between Vilajuïga and Garriguella. Dalí, as he admitted some years later, would have put a rhinoceros inside it so that the tourists would pay to see it.

The solution to the dilemma had its source in the journalist Enric Sabater, who would later become the couple's secretary. Sabater had a pilot's license: this enabled him to fly over the land and take aerial photos of the possible places. On one of these flights he discovered a large medieval house in Púbol, in Baix Empordà, and he showed photos of the area to the couple. The snaps aroused Gala and Dalí's interest, and they decided to go there to give it a look over.

The castle of Púbol, surrounded by a walled garden, was in a fairly ruinous state: nevertheless, the artist was enthused by the visit. As Emili Puignau recalls,

Dalí exclaimed, "Magnificent, it's fantastic. It is worth buying if only for the courtyard. I have also seen something sublime on the facade: not only is it cracked, it also forms a projection in the crack that gives the impression of there having been a cataclysm, an earthquake; one part holds fast and the other is collapsing. This means that it shouldn't be touched. It must be left just as it is". The advice would be followed to the letter throughout the restoration of the castle.

One of the side walls of the building was attached to the church of Sant Pere de Púbol, built, as a castle, in the mid-14th century. The church had been presided over by the Altarpiece of Sant Pere, considered one of the key pieces of Catalan Gothic art. The work of the painter Bernat Martorell, it was removed from Púbol in 1936, when the Bishopric of Girona hid it in order to save it from the ravages of the Civil War. The day the castle comes under the ownership of the Dalís, the son of Figueres will try to recover the Gothic piece with the unstated aim of incorporating it into his museum. However, the conversations with the Bishopric will make it clear to him that he has no rights whatsoever over the altarpiece.

The negotiations to purchase the fortress began in 1969: the estate included an irrigated orchard, located on the Púbol plain, a pine tree wood and some dry land. The Dalís gave the owners of the castle an advance payment and agreed to pay the rest when the deeds of sale were ready. All the paperwork completed, the couple settled in Paris for a while, but they wanted to have the building ready on their return. Puignau, who had been entrusted with the successive extensions to the house in Portlligat, had to undertake the rehabilitation work in record time: barely seven months.

The following April, when the Dalís returned to Cadaqués, the castle was now ready and the deeds could be signed. Gala spent the whole summer busy visiting antique dealers to choose the furniture. The painter, meanwhile, prepared the decoration of some parts of the building. Gala was nervous at the prospect of moving into a new home, but she would have to wait until 1971 before becoming the owner. Despite the fact that Gala read her Tarot cards every day, the secrets were never revealed to her of the sinister role that the future held for her in the fortress.

The muse's hidden kingdom

Gala usually spent short stays in the castle of Púbol. She would generally stay there during the summers, for periods of between two and three weeks. Practically nothing remains of her presence there except for the photos taken by the photographer Marc Lacroix. Gala did not like having her photo taken very much, but shortly after moving in to the residence, Dalí obliged her to accept a photographic session. This was the first and last professional illustrated report that would be made of her inside the castle. Despite her mistrust of cameras, Lacroix managed to have her posing smiling and relaxed. Her eyes sparkle with satisfaction in the photos. You can see that she is proud of her property.

As soon as she had settled in, Gala took her role as host of the castle very seriously indeed: everything had to be just as she wanted and the doors would only be opened to whomever she wanted to see. The legend goes, spread by Dalí himself, that this command also applied even to the painter, who had to announce his visits with advance notice. The artist, with his usual humour, said that this pact of non-intrusion fêted his masochistic feelings. Nevertheless, knowing Dalí's impetuous character, one supposes that if he had wanted to turn up suddenly, nothing and nobody would have been able to stop him.

In any case, the castle of Púbol is the opposite of the house in Portlligat: it is made to Gala's taste. Its noble walls with stone coats of arms, the Gothic windows and the high and spacious rooms are very much in accordance with the Russian's bitter and aristocratic character. The place gives off a feeling of austerity and withdrawal, very far from the wild excessive craziness of the house in Cadaqués. Emili Puignau recalls that the artist proposed, nearly every day, mad ideas to embellish the fortress. Gala firmly opposed them: "The castle is mine", she exclaimed, "and you have no say whatsoever in anything to do with it". Perhaps due to this response and for the appeal that the future Theatre-Museum held for him, the painter ended up losing interest in Púbol and left some aspects of the fortress unfinished. At least this is the sensation it gives off. It is true that Dalí's touch is revealed to us through several trompe l'oeil, paintings on the walls and ceilings, the new design of some of the rooms or the presence, almost inevitable, of some or other stuffed animal. The moderation and the size, however, are standard. In Púbol, the creator is always held back.

Without the slightest doubt, the garden that stretches out in front of the house is one of the most "dalinised" parts of the property. It is a leafy and exuberant garden, full of plane trees, cypresses, ivies, mulberry trees, oleanders and bushes, from which a romantic and decadent air oozes out. The painter's interventions aimed to emulate, on a small scale, the park of Bomarzo that had astonished him so much. The playful nature of the space is emphasised by different optical tricks and the labyrinthine positioning of the paths. The side and central paths mischievously go into the vegetation and lead, through the wooded part, to long-legged concrete elephants.

At the end of the garden an extravagant swimming pool appears, overlooked by a shrine of Hellenic airs. The artist decorated it with two caryatids and a font sculpted with a child riding a fish. The ceramic pieces come from a house in Figueres. Dalí had been really impressed by them in his childhood and did everything he could to persuade their owners to sell them. The ensemble is completed by an alarming angler fish, showing its teeth, as a water spout. On both sides are coloured busts of Richard Wagner, one of the painter's favourite musicians. The amalgam of influences ratifies its creator's fondness for kitsch and the grotesque. The sum of such elements produces a kind of enchanted wood, a capricious garden that makes one think of Alice in Wonderland and Lewis Carroll.

The explosion of plantlife in this mysterious garden is reflected on the inside of the castle, in the painting that decorates the ceiling of the Coat of Arms room, the castle's elegant vestibule. The work, much simpler than the other Dalinian murals, shows some swallows in circular flight over a misty wood. Gilded walls and columns emerge from the clouds and culminate in a skylight through which we see a night charged with fantastic elements. Beneath the waning moonlight, crossed by a cloud, a harras of horses and some angelical women descend from the sky, as if they wished to offer a tremendous welcome to the visitors who dared to venture into Gala's dominions.

The Coat of Arms room is one of the small palace's rooms where we find more of the painter's works. Apart from the sumptuous ceiling, the walls display shields illustrated with esoteric emblems. Undoubtedly, however, the most stunning decorative element is a false door, painted with maniacal and hyperrealist exactness, which gives the false impression that it can be entered. The adjacent furnishing is made up of an altar, of a bronze chair decorated with spoons and of a small stage, with a blue canopy, that carries the name of The Marquis's Throne. The throne is a chair with gilded arms, over which is painted the sun rising over the plain of Púbol. The seat is flanked by two golden columns and a pair of wooden lions. Dalí conceived this setting in 1984, with the idea of receiving journalists while seated there. The name of the whole set refers to the noble title of Marquess of Dalí and of Púbol, which King Juan Carlos I had awarded the artist two years before.

So that nobody forgets that this is Gala's house, a representation of her, in the form of an angel with a severe expression, stands over the door that leads to her private rooms. If we enter we reach the Piano Room, which fulfilled the role of a living room. The name comes from the piano that Jeff Fendholt usually played: he was the star of the musical *Jesus Christ,* *Superstar* and a regular guest at the castle. The red curtains and sofas contrast with the clean white walls, decorated with large tapestries.

The room also shows different Dalí originals. The most notable is *Gala's Castle at Púbol* (1971-1973): it is one of the few painted references to his wife's home. The oil painting was a gift from the artist that he gave her on the day the castle was opened and, naturally enough, Gala is the total star of the piece. The muse appears not once but twice: with her back to the scenery, dressed as a sailor, and flying the banner that emerges from the fortress, on the left-hand side of the painting. In the centre of the plain of Púbol some very tall poplars rise up and a narrow path is outlined along which are walking a farmer and horse. The most interesting part, however, occurs in the distance, above the clouds: the cupolas of Russian orthodox churches can be made out, like a hallucination produced by the rising sun.

Perhaps it is no coincidence that this image is located in part of the room where we come across other visual tricks, such as the trompe l'oeil of the radiators, which was designed to solve the problem of Gala being bothered by the visual presence of them. To cover them up, they were hidden behind a metal sheet and Dalí, with a gesture befitting Magritte, painted some false radiators over them. If we approach the circular table with ostrich feet we will discover another trick: we can see the stuffed horse on the floor below, where today the castle shop is located.

On the other side of the room, between the piano and a lithograph of Saint George and the Dragon, is the door to Gala's private room. This room is decorated in shades of blue: the curtains, sofas, baldaquin and bed, complemented by the golden reflections emanating from the candelabra and from a majestic mirror. Next to the headboard of the bed there is a small entrance that leads to the old castle kitchen. Gala reconverted the space into a dressing room,

decorated with Andalusian and Dutch ceramic tiles with which Dalí wanted to pay homage to his maestros Velázquez and Vermeer de Delft. The dressing room, where a small washbasin was fitted, was a very important piece for Gala. Being concerned about her physical appearance ended up as a minor obsession which resulted in subjecting herself to several plastic surgery operations.

Though Dalí was careful about his public image, his wife left him standing in this aspect. The best way of showing this is to visit the castle loft where there is an exhibition of the different dresses the muse wore between the forties and the seventies, and which feature in some of the paintings. The dresses bear the label of top-class designers such as Christian Dior, Pierre Cardin and Elizabeth Arden. The *barretina*, the Catalan cap, that the painter wore, accompanied by his famous country shirt in blue tones, are the counterpoint to Gala's extreme elegance. When the painter wore this uniform, he seemed more like a bit player in an American television soap opera than a renowned artist.

The twilight of the marquis

Gala had an operation on her femur in March 1982. After that operation she lost her vitality and her appetite and, little by little, her light began to fade. Dalí, aware of the inevitable outcome, surprised his collaborators and requested that, when they died, Gala and he be buried in the basement of the castle of Púbol. The request caused quite a furore amongst the people around him. Emili Puignau stated, "We had always thought that, as he was so much in love with Cadaqués, he would want to be buried in the village cemetery where his family was also buried".

Gala had already stated on several occasions of her desire to be buried in Púbol, but Dalí had always had a rather distant relationship with the castle; making a 180-degree turn, he now preferred to convert the basement into the crypt of his eternal rest. The painter wanted a very simple, double tomb, separated by a partition. The sepulchres would be covered with two gravestones, without adornments or inscriptions. The work was undertaken with great urgency.

The basement of the castle was given the name of *Delme*, tithe in English, because, in the Middle Ages, the peasants from the surrounding area would come there to pay taxes to the feudal lords. When the Dalís bought the fortress, there were some large earthenware jars in the room because it had been used as a cellar. Since Gala had not thought about using it, its rehabilitation was never a priority. The space attracted Dalí, however, who designed a handrail for the basement stairway. The handrail was never made, but what was undertaken, however, was the transformation of the floor into a gigantic chessboard in homage to Marcel Duchamp. Today the black-dyed tiles have lost their colour, but a pair of horses' heads, an athletic torso and a stuffed giraffe, behind the tombs, recalls that idea.

The 10th of June 1982 was a sad day. Gala's death occurred while the couple were in Portlligat. The painter's Cadillac served as an improvised ambulance: Dalí's

chauffeur, Artur Caminada, and a nurse transported the lifeless body to the Baix Empordà. The artist arrived at the castle on the second journey, accompanied by the oil painting *The Three Glorious Enigmas of Gala*, completed just a few weeks before, and a photo of Helena Diakonova with the King and Queen of Spain. Dalí had his wife's body embalmed so that it would resist the passing of time and then shrouded her in her red dress by Dior. The funeral was held the next day, in a very brief, emotive and private ceremony. From that day on, a simple cross marks the final resting place of the woman who was the muse, companion, mother, wife, manager and administrator of the most impulsive of the surrealists. Shortly after the burial, Dalí decided to go and live in the castle. The house in Portlligat was too painful for him for it contained too many memories. He was never able to return there.

During the first months in Púbol, Dalí's level of activity was minimal. He took short walks around the garden and painted a few pieces. The first floor dining room, connected at one end to the Coat of Arms room, became the new studio of the artist from Figueres. He painted alongside a very original fireplace which he himself had designed: the double curvature of the lintel, he said, was inspired in some way by a drop of water before disintegrating.

Due to the physical difficulties that he experienced, Dalí was assisted in these creative works by one of his regular helpers. As he liked to paint with someone reading in the background, sometimes a nurse read him texts by René Thom. In fact his very last oil painting, titled *The Swallowtail*, was in homage to the mathematical discontinuity discovered by Thom. The piece was ready in April 1983 and Dalí was photographed with it wearing a white tunic and astrakhan cap. After this painting, simple but allegorical, the artist from Figueres put away his brushes and palette forever.

Today, an easel, situated just between the two large terrace windows, reminds us of these final glimmers

of pictorial energy. Just in front there is an armchair covered in white cloth. The material still has a few traces of paint and stains, because Dalí wiped his brushes on it so he did not have to move. Antoni Pitxot, friend and confidant of the artist, was present at many of these sessions: "Dalí always painted sitting down. He painted with the room in semi-darkness. Dalí did not need the overhead light that we everyday painters need. The light was in his head. He did not need either light or models". The only beacon that lit him at that time was the bust of Gala, crowned by a drop of milk.

As the days went by, an ineluctable sadness gradually took over the artist until he fell into a state of acute depression. Little by little, the manias he had were emphasised: he refused to see daylight or to leave the castle for medical examinations. He would not receive visits either. The most serious problem, perhaps, was his stubbornness in refusing to eat. Ensuring that Dalí tried something to eat was a formidable feat.

To stimulate his appetite, his collaborators took him menus from the prestigious Hotel Empordà in Figueres, his intimate friends took him sea urchins from Cadaqués and, as a last resort, ordered a jar of pâté from a prestigious restaurant in Paris. All efforts were useless, however: he did not want to eat anything, except for the mint sorbets that were prepared for him in the Figueres hotel. Due to his behaviour, as the illness got increasingly worse, Dalí became a nightmare for his own circle and for the nurses that had to look after him.

This chaotic situation came to an abrupt end on the 30th of August 1984, when Dalí accidentally caused a fire. The painter always rested in Gala's old bedroom. To get in contact with the domestic service, his bed had a manual switch that operated a bell. The artist pressed it with an obsessive, monomaniac constancy. Each time he touched it, however, electrical sparks flickered inside. In the small hours of that

night, one of the sparks set light to the sheets and, in a question of seconds, the room filled with smoke. Dalí was rescued from the fire: meanwhile the fire service and doctors were called.

The fire destroyed the room but the artist seemed to be unharmed. Apparently, he had only suffered light burns, but after twenty-four hours they realised that it would be a good idea to admit him to hospital. The painter agreed to go, but placed as a condition an immediate visit to the works on the extension of Torre Galatea. His circle agreed and Dalí was driven there and he checked the works that connected the Theatre-Museum to the old mansion.

Dalí would never again return to the castle of Púbol. When he was let out of hospital, on the 17th of October, his Cadillac stopped in Figueres and the artist was moved into the rooms of Torre Galatea. This was his last home. He would stay there, in voluntary isolation, until his dying day, the 23rd of January 1989.

The decision to go and live in the old Casa Gorgot had been on his mind while he was in Púbol. Dalí had never stopped thinking about the enlargement of the Theatre-Museum and, despite the physical distance, had decided on the basic details of the outside decoration: from the reddish colour of the façade to the yellow of the *pa de crostons*, along with the positioning of the eggs on the roof. From his retreat in Baix Empordà, the artist had told the press that the Torre Galatea would be a unique monument: it would contain the secret relics of the voyage of the Argonauts, guarded by the inscription "Entry prohibited to all those who are not heroes."

The artist's retirement to Figueres was a gesture that was greatly esteemed by his co-citizens. Everybody was aware that Dalí, the unbeaten hero of contemporary art, had wanted that building to be the setting for his final metamorphosis, the most important of all: his immortal renaissance in the form of myth and legend.

GALA DALÍ

vous attend

au Château de Púbol

le

à partir de

Carta de Amor

Al dirigir a ti, este escrito
quisiera yo expresar en él,
todo el dictado de mi alma
junto a los latidos del corazón
que dicen: TE AMO, ¡vida mía!

De un amor inmenso y sublime
en mi constante ilusión,
mi mente siempre está,
y en mi corazón quiero
¡guardarte,

amo y la vida con-
¡sagrarte.

o. Así te adoro,
de mis sueños de oro,
donos nunca jamás
ontigo, pienso vivir

Automatic Beginning of a Portrait of Gala, 1932. Dalí Theatre-Museum, Figueres

In private Dalí called Gala *oliveta* (little olive). For this reason he drew
the crown of an olive tree in her hair, as if she were an Empordà Daphne.

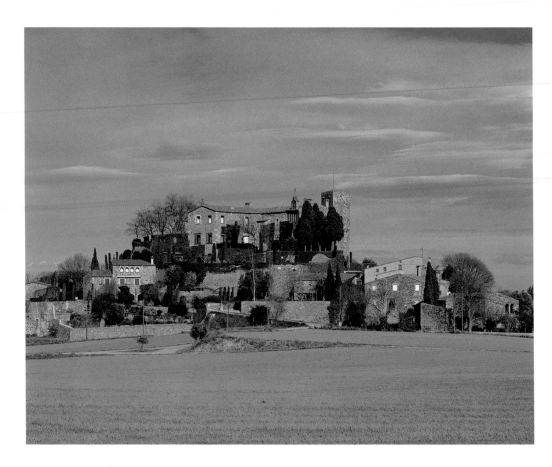

The Baix Empordà has a mild, rolling and gentle landscape that has made
it the delight of travellers seeking relaxation and peace. Its magnificent past, visible
in the walls of Foixà, is complemented by a strong agricultural tradition.
It was here that Gala found the oasis of calm that she had lost in Portlligat.

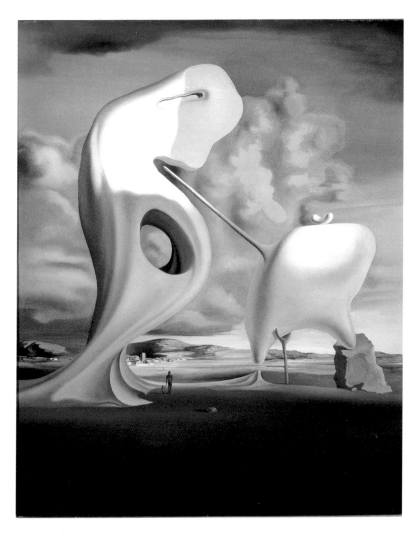

THE ARCHITECTURAL ANGELUS OF MILLET, 1933
National Museum of Art Reina Sofía

VIEW OF PÚBOL, 1971. House-Museum Castell Gala Dalí, Púbol

The streets of Púbol preserve the rural flavour that was so much
to Dalí's liking. The presence of Gala represented the return
of the aristocratic glamour to the walls of the old barony.

"THE CASTLE OF PÚBOL IS MAGNIFICENT, IT'S FANTASTIC. I LIKE IT. IT IS WORTH BUYING IF ONLY FOR THE COURTYARD"

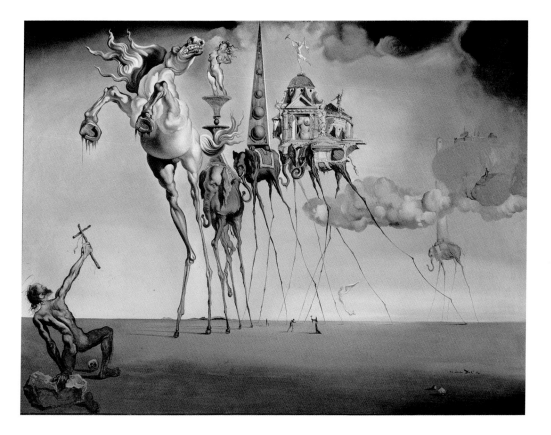

THE TEMPTATION OF SAINT ANTHONY, 1946. Musées Royaux des Beaux-Arts de Belgique, Brussels

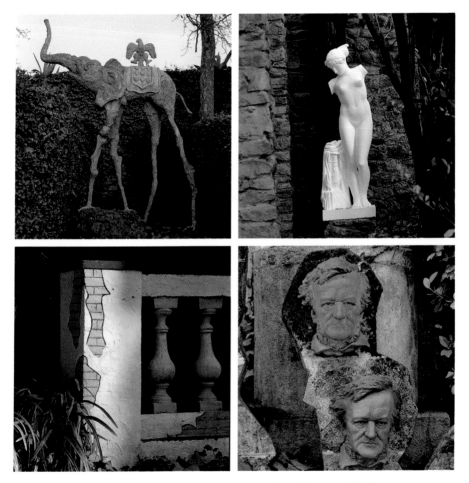

The artist's imagination converted the gardens into a labyrinthine game, full of monsters, sculptures and visual surprises, in the same way as in the Italian park of Bomarzo. The way ends at the swimming pool with a fountain, flanked by coloured busts of Richard Wagner.

"FOR NORMAL PEOPLE, THE PAINTER'S SUCCESS BEGINS ON THE DAY THE PAINTER BUYS HIMSELF A CAR. EVEN BETTER STILL, HOWEVER, IF AS WELL AS THE CAR, HE HAS A SMART CHAUFFEUR AND A FOOTMAN. IT IS THE EVIDENCE, FOR THOSE OUTSIDE, THAT HE EARNS A LOT OF MONEY"

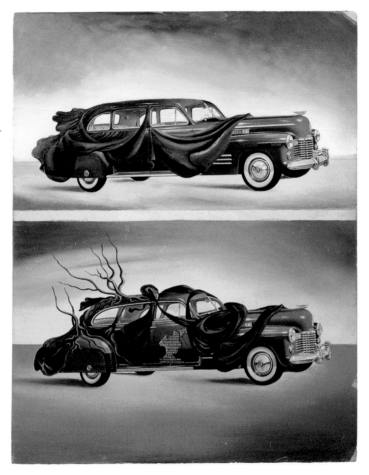

CAR CLOTHING (CLOTHED AUTOMOBILE), 1941.
Dalí Theatre-Museum, Figueres

The stairway of the castle leads us to the Coat of Arms Room. The reception contains heraldic coats of arms, the painter's throne and a piece of furniture with white material that serves as an altar. These titled symbols are complemented by brilliant *trompe l'oeil* paintings arranged on the wall and ceiling.

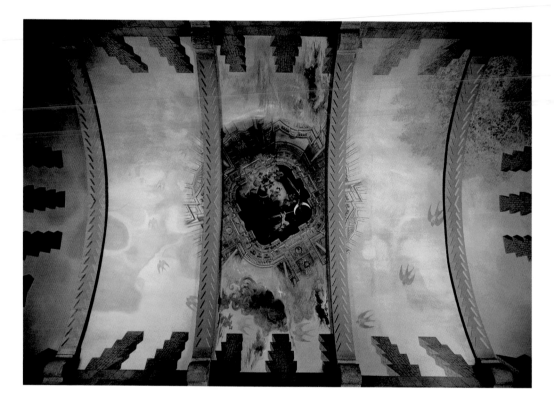

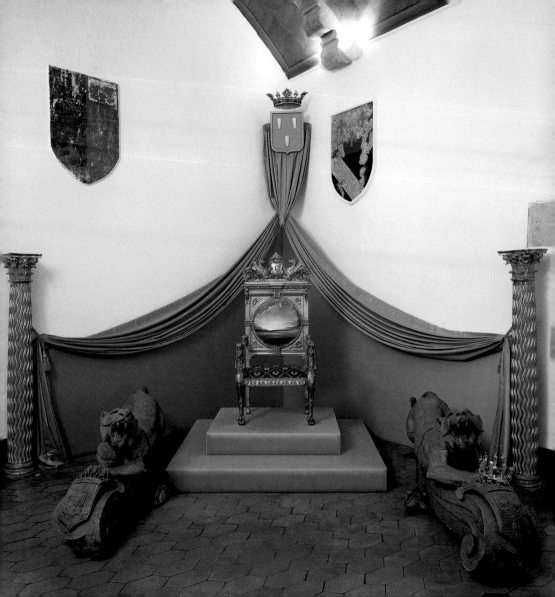

GALA'S CASTLE AT PÚBOL, 1971-73. House-Museum Castell Gala Dalí, Púbol

Luxurious tapestries and doors. Candelabras, sofas in an explosive red colour and ostrich legs on the small table. The piano room was a place of rest for Gala.

"I WILL GO TO THE CASTLE WHEN GALA ALLOWS ME. BECAUSE IT IS HERS AND SHE WILL USE IT TO CUT HERSELF OFF"

The Dutch ceramics and the golden taps contrast with the bare washbasin. The decoration
in the large house is a constant dialogue between the personalities of Dalí and Gala.
Her taste can be made out in the delicateness of the dressing table.

Gala was a music lover and had a passion for books. The old library shows
evidence of these great loves, to which should be added her fondness for games
of intelligence. Dalí designed a chess set as homage to Marcel Duchamp, who he
had seen playing interminable games in the Melitón bar in Cadaqués.

The flame red, the colour of unbridled passion, acted as an invitation card to the guests at the castle. Gala chose them with the painstaking care of an entomologist. The friends of the surrealist muse were warmly welcomed in the red room.

In the loft of the building we come across the most exclusive dresses worn by Gala: astonishing creations by Christian Dior, Pierre Cardin and Elizabeth Arden. Dalí also tried his hand in the sphere of haute couture, with some spectacular results.

A small but well-exploited kitchen. Gala and Dalí were excellent gastronomes with an exquisite taste. They always kept well away from the stoves.

The castle's dining room, crowned at the end by an aerodynamic chimney, was the studio where the artist created his last paintings. Not far from his easel, a cupboard guards a mollusc with the face of Gala, a Christ painted on a stone and another, in metal, bent over on the cross.

In the basement of the castle, in the old tithe room, lie the remains of Gala. Her body was buried beneath the right-hand tombstone. The princess who came from Russia and her surreal knight, Salvador Dalí, now form an indissoluble part of the epics and legends of these lands.

Bibliography

DALÍ, ANNA MARIA, *Noves imatges de Salvador Dalí*, Barcelona, Columna, 1988.

DALÍ, SALVADOR, *L'alliberament dels dits*, Barcelona, Quaderns Crema, 1995.

DALÍ, SALVADOR, *Un diari: 1919-1920: les meves impressions i records íntims*, Barcelona, Edicions 62, 1994.

DALÍ, SALVADOR, *Diario de un genio*, Barcelona, Tusquets, 1998.
 (In English: *Diary of a Genius*, Creation Books, 1998).

Dalí, Salvador, *Vida secreta de Salvador Dalí*, Figueres, DASA Edicions, 1981.
 (In English: *The Secret Life of Salvador Dalí*, Dover Publications, 2000).

GIBSON, IAN, *La vida excesiva de Salvador Dalí*, Barcelona, Empúries, 1998.
 (In English: *The Shameful Life of Salvador Dali*, Faber and Faber, 1997).

GIMÉNEZ-FRONTÍN, J.L., *Teatre-Museu Dalí*, Barcelona, Tusquets/Electa, 1994.

MAS, RICARD, *La vida pública de Salvador Dalí*, Barcelona, Ara Llibres, 2003.

MASANÉS, CRISTINA, *Lídia de Cadaqués*, Barcelona, Quaderns Crema, 2001.

PITXOT, ANTONIO / AGUER, MONTSE, *Casa-Museu Salvador Dalí Portlligat*, Barcelona, Escudo de Oro, 1998.

PITXOT, ANTONIO / PLAYÀ, JOSEP, *Casa-Museu Castell Gala Dalí, Púbol*, Barcelona, Escudo de Oro, 1998.

PLA, JOSEP / DALÍ, SALVADOR, *Obres de museu*, Barcelona, Parsifal Edicions, 1997.

PLAYÀ, JOSEP, *Dalí de l'Empordà*, Barcelona, Editorial Labor, 1992.

PUIGNAU, EMILIO, *Vivències amb Salvador Dalí*, Barcelona, Editorial Juventud, 1995.

RODRÍGUEZ AGUILERA, CESÁREO, *Dalí*, Barcelona, Edicions Nauta, 1985.

ROMERO, LUIS, *Todo Dalí en un rostro*, Barcelona, Blume, 1975.